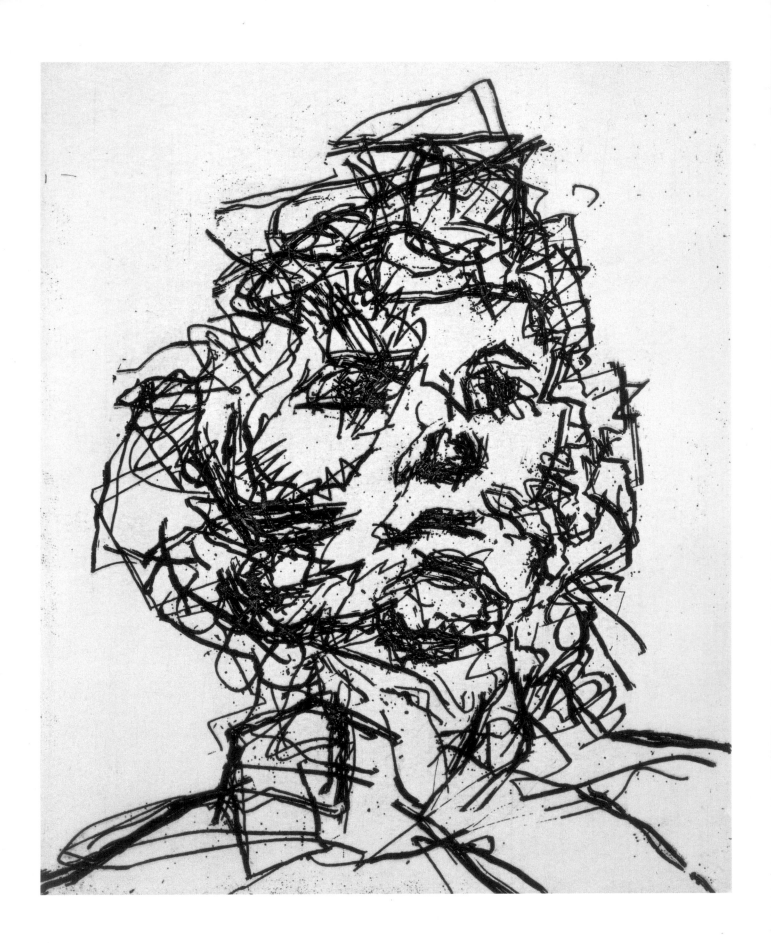

DRAWING

MASTERING THE LANGUAGE OF VISUAL EXPRESSION

KEITH MICKLEWRIGHT

Laurence King Publishing

LAURENCE KING

Published in 2005 by Laurence King Publishing Ltd
71 Great Russell Street
London WC1B 3BP
United Kingdom
Tel: + 44 20 7430 8850
Fax: + 44 20 7430 8880
e-mail: enquiries@laurenceking.co.uk
www.laurenceking.co.uk

A catalogue record for this book is available
from the British Library

ISBN 13: 978-1-85669-460-5

ISBN 10: 1-85669-460-7

Designed by Price Watkins
Cover design adapted by Price Watkins
from a concept by Brankica Kovrlija
Picture research by Gill Metcalfe
Glossary compiled by Jennifer Speake
Index compiled by Ursula Caffrey

Figures 3.1, 3.2, 3.3, 3.4b, 3.5, 4.1, 4.2, 4.6, 4.10, 5.1, 5.2, 5.3, 5.4, 5.5,
6.2, 7.5, 7.9, 7.15, 11.5, 11.6, 11.7, 11.8, 12.3 are all digital renderings
by Advanced Illustration Ltd from original drawings by Keith Micklewright.

Printed in China

Frontispiece: Frank Auerbach (b. 1931). *Jake*, 1990. Etching, from an edition
of 50, 10 1/4 x 8 1/2 in. (26 x 21.5 cm). Private Collection.
© The Artist. Photo: The Bridgeman Art Library.

Front cover: (Main image) Detail of Samuel Palmer (1805–81).
Self-portrait, 1824–25. Black chalk heightened with white on paper,
11 1/2 x 9 (29.1 x 22.9 cm). The Ashmolean Museum, Oxford.
(bottom row) Keith Micklewright (b. 1933). Details of five drawings
(see pages 37, 50, 72, and 92).

Back cover: Keith Micklewright (b. 1933). Three chairs, 2004. Pencil on paper.

Contents

Preface

Drawing is fundamental to and at the core of the artists' and designers' work. It is the means by which artists learn to see and understand the world in the first place. Later, drawing becomes their primary method of research, designing, and communicating ideas to others. The simple materials required allow freedom, spontaneity, and the possibility of immediate selection and amendment to occur. Drawing is the starting point and catalyst for most artists' and designers' ideas and work.

The idea of drawing being considered as an extremely subtle and sophisticated language encourages its full variety and potential to be properly understood. Like the words in an essay, the marks in a drawing are the equivalent of, not the same as, the subject described. A drawing, by its very nature, has to be selective and does not aspire to be imitative or photographic. It is a translation of an idea or observation into a new form.

To be illiterate would cause problems for somebody wishing to write an essay. Being visually illiterate is the main obstacle to producing a drawing. This book considers ways of learning the language of drawing and understanding the visual "words and grammar" needed to make drawing possible.

Acknowledgments

For a number of years I worked with an exceptional group of staff on the Foundation course at Bournemouth and Poole College of Art (now The Arts Institute at Bournemouth). A major concern and preoccupation was the teaching of drawing, and one of the things this book attempts is to encapsulate some of the ideas about drawing that were developed and refined over several years on this course. The members of the group involved in teaching various aspects of drawing included Peter Arnold, Howard Brown, Roger Dade, Alan Denley, Said Dia, Eddy Foulstone, Peter Hand, Debbie King, Peter Malone, Mavis Muir, and Rachel Skeet. I am indebted to them all.

My thanks to Professor Kate Hixon of the Pratt Art Institute, New York, for reading an early draft of the book and encouraging my further efforts.

A particular pleasure for me, resulting from writing this book, has been the oppoertunity to work with most friendly and professional people at Laurence King Publishing. Lee Ripley Greenfield first expressed interest and did not show me the door. Lesley Henderson introduced me to the complexities of book publication.

Gill Metcalfe tirelessly searched for the illustrations, Jennifer Speake corrected my manuscript and prepared the glossary, and Price Watkins produced the handsome design. Finally, Anne Townley and Donald Dinwiddie most tactfuly edited and guided the book to publication. All have my admiration and appreciation.

I very much valued the comments and suggestions made on the draft manuscript by the reviewers. Their identities were unknown to me at the time, but their names can now be revealed: Aj Smith of the University of Arkansas at Little Rock and Ronald Cohen of the University of Iowa.

Without my family's interest and involvement, the book would never have been written. My three children, David, Lisa, and Emma, were the initial catalysts, first suggesting that I write the book, criticizing the manuscript during its various stages, and designing and producing the early first proposal. Finally, my wife, Jane, patiently read, discussed, and improved the book at every stage. Many thanks to each of them.

Keith Micklewright, October 2004

The Origins of Drawing

THE need and ability to communicate complex ideas is a uniquely human attribute. Sound and gesture are probably the oldest form of human communication, but drawing is at least 20,000 years old and is a much older and more basic human activity than writing.

It is unlikely that a neolithic artistic genius just appeared 20,000 years ago and immediately disappeared down the nearest cave to produce art. There must have been many more modest and less permanent attempts to make marks and likenesses over many preceding years before a drawing was made. However, the first known drawings we have are on the walls of caves, most famously at Lascaux in France, although there are examples in many other places (**1.1**).

Over the millennia some drawings evolved into signs that could convey simple messages. About 5,000 years ago symbols with an agreed meaning appeared, which can be identified as writing. This occurred in Mesopotamia (now modern Iraq) and the Indus Valley (now modern Pakistan), and later in Egypt and China. Egyptian hieroglyphics, in particular, show their relationship to beautifully observed drawings of natural objects (**1.2**). Although the original sources are less obvious, Chinese writing also developed drawings into ideograms and, in turn, to modern Chinese characters. In many non-Western societies art and calligraphy are closely linked, as drawing and writing often require similar craft skills and aesthetic awareness.

Written language has developed in two forms: phonograms, where signs represent the sounds of spoken language, and pictograms, which represent ideas and are unrelated to the sound of the language. Pictograms are self-explanatory (**1.3**), but phonograms, more commonly described as an alphabet, can only be understood by knowing the spoken language. The alphabet also made it easier to represent concepts as well as objects, allowing abstract ideas to be articulated. With the development of the alphabet, drawing and writing developed their separate roles, with writing now dominant in that we think largely in words. Drawing is seen as a minority activity of value to artists and designers, rather than as an alternative means of communication and expression.

Verbal language generally operates with "universals," requiring considerable elaboration to describe, usually rather imprecisely, the "particular." Drawing, in contrast, is seldom universal, nearly always describing the particular. The word "head" does not describe a particular person's head, whereas a drawing of a head is always unique and individual. Drawing can be better than words in communicating all kinds of information. It is revealing to notice that when a professional artist or designer wants to explain an idea to somebody, he or

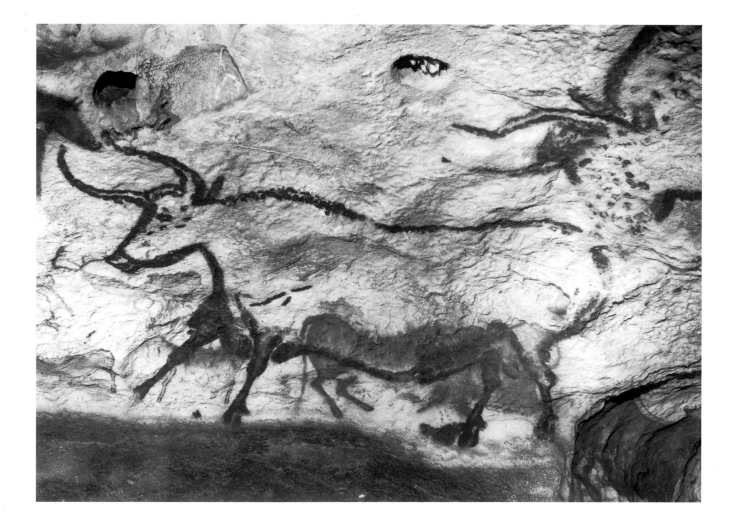

1.1 Bull. Lascaux cave, c. 12,000 BCE.

This drawing is probably about 14,000 years old. The difficulties of working on a rough stone surface, using primitive tools and pigment, would make the production of any drawing remarkable. It is even more amazing that a drawing of such vigor and subtlety was made in the semi-darkness of a cave. The rhythms and variety of line that were used display a degree of sophistication equal to that of any drawing produced in the intervening millennia.

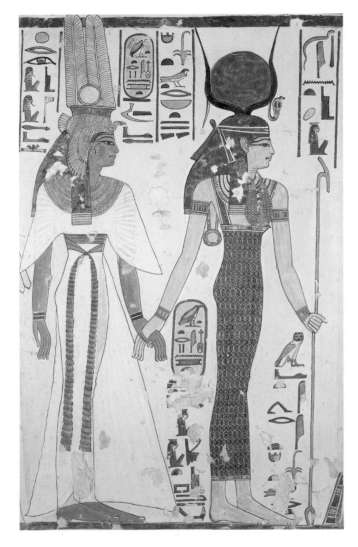

1.2 Nefertari and Isis. Tomb of Nefertari, Thebes.
c. 1297–1185 BCE.

The hieroglyphs that surround the two
figures are a strange mixture of almost
naturalistic drawings and stylized symbols.
However, because they both conform to a
rigid set of design principles, they have a
unified appearance, which is important for
legibility in any form of writing.

she usually does a drawing, but an inexperienced art student will still use words. A momentous turning point for art or design students occurs when drawing becomes as natural a mode of communication as talking or writing.

DRAWING IN THE PAST

The reasons artists have had for drawing and the various conventions and styles they have used over the years are always pertinent to the present-day artist and designer. These reasons and conventions have obviously not remained static over the centuries and it is sometimes difficult to imagine how artists in the past viewed their role, let alone their reasons for drawing.

An Egyptian artist 4,000 years ago would not have understood our idea of an artist. He would have been considered to be only an artisan, with a very prescribed artistic tradition in which to work. He was not expected to produce a drawing of a human figure seen from one position but to build up a synthesis of parts seen from "ideal" positions. The head was drawn in profile, but the eyes from the front, the shoulders from the front, and legs from the side, as seen in the figures from a frieze in a tomb at Giza (**1.4**). The existence of a strong linear drawing style nevertheless gave these disparate views a convincing unity. Yet in spite of a regime that never countenanced the representation of sloping surfaces, and that contemporary artists would find intolerably restrictive, he must have been able to remain visually curious. It is a matter of speculation as to whether he was aware of the strange dichotomy in Egyptian art between extreme convention and acute observation. Somehow the ancient Egyptian artist was inspired to make some of the most strikingly subtle images of plants and animals ever produced (**1.5**).

For most of history, the way an artist worked and was educated has been unlike the present. Until the Renaissance in the fifteenth century the artist, in the contemporary sense, hardly existed and was considered to be an artisan/craftsman. The main exception was the relatively brief period of classical realism in Greece around the fifth and

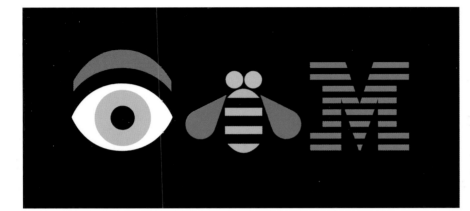

1.3 Paul Rand, *IBM,* 1981.

Even today a form of hieroglyphics can be used and is easily understood. This brilliantly simple and witty rebus was designed in 1981 by the eminent American designer Paul Rand.

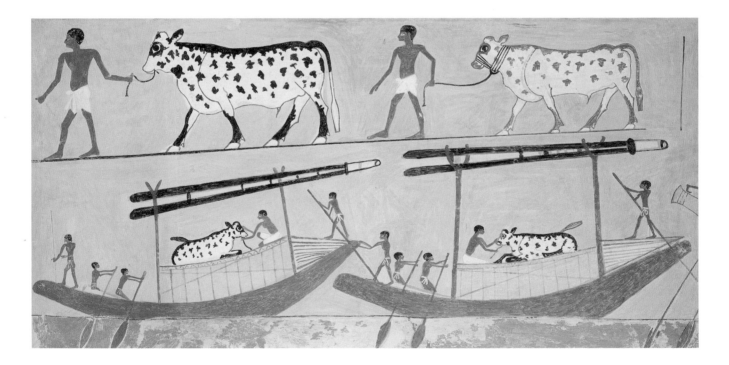

1.4 Cattle and Boats on the Nile. Private tomb of Kaemankh, Giza, 2650–2135 BCE.

The contrast between the formulaic way the human figures are described and the detailed observation of the cattle is striking. This strange dichotomy does, however, work visually, being given unity by the frieze-like design reinforced by the total lack of any attempt to portray any depth.

fourth centuries B.C.E. when the individual artist, particularly the sculptor, flourished. Significantly, it was the rediscovery of this art that helped produce the Renaissance nearly 1,800 years later.

From Byzantium to medieval Europe, all powerful religious and political bodies dictated the role of art in society. Art at this time was inevitably concerned with "universals," not "particulars" and depicting these "truths" in acceptable and potent imagery for the illiterate masses was its ultimate focus. This in effect meant that art created the artist/craftsman, rather than that the artist created art. The medieval artist was required to learn the correct formulas by studying copybooks, for example those by the early thirteenth-century Frenchman Villard de Honnecourt (**1.6**). He superimposed simple geometric shapes, such as squares, rectangles, or triangles, onto heads, figures, and animals. With the aid of these very basic constructions a novice could establish the "correct" proportions for a whole range of objects. Copying the work of established masters was also an important method of learning to draw. The quality of a drawing was judged by the perfection of the workmanship, not by its originality. In Cennino Cennini's craftsman's handbook *Il Libro dell'Arte* (c. 1400) he advises, without any sense of irony, that the apprentice copy only one master, not several, to assure "a manner individual to yourself."

With the emphasis on craftsmanship and the medieval aesthetic that only the complete was regarded as perfect, the idea of a sketch in the modern sense could not exist. Usually a drawing and a painting would have been a single inseparable process not requiring independent preliminary drawings. Another factor militating against drawing in our sense of the word was that until about 1300 C.E. paper did not exist in the West and proper drawing paper not until

1.5 Frieze of Geese. Mastaba (tomb) of Het, 2630 BCE.

This beautiful description of geese is a wonderful example of the ancient Egyptian artist's individuality. The intensely observed details suggest a real curiosity about the visual world, in spite of the very rigid prescription that was laid down for the production of most of his art.

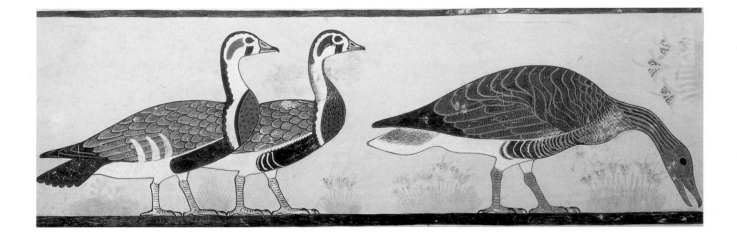

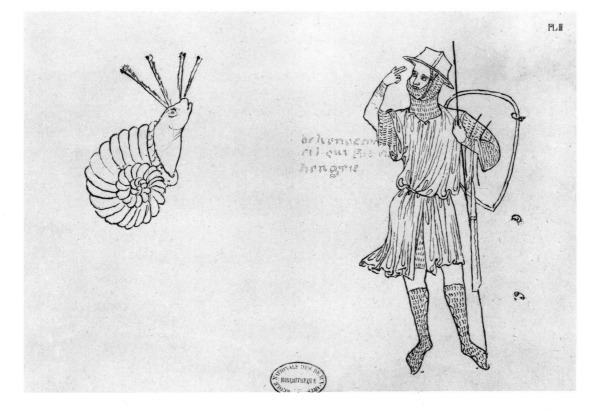

1.6 Villard de Honnecourt. *Snail and Hungarian Soldier*, early 13th century. Bibliothèque d'École des Beaux-Arts, Paris.

The quality and personality of Villard de Honnecourt's work distinguish it from the very stylized drawings of most medieval artists — ironically, educated on the copybooks he produced. Although he worked within the very linear manner of the period, his lines have a vitality and variety that are unusual for a medieval drawing.

about 1500. The medieval artist drew on specially prepared boards or on parchment, both cumbersome and expensive.

The fifteenth century was a time of dramatic change and saw the beginnings of the Renaissance. There were a number of factors that contributed to this revolution, not only in art, but also in society. The main catalysts were the rediscovery and greater understanding of classical art, a renewed interest in science, and the changing and broadening of artistic patronage to include wealthy individuals as well as the church and state. The perception of the artist by society also changed. Until the fifteenth century most "artists" were monks or artisans, and the children of middle-class families hardly ever chose artistic professions. The father of Michelangelo (1475–1564) opposed his son becoming a "stone cutter" and consented only after Lorenzo the Magnificent explained to him the difference between a stone cutter and the "new" occupation of sculptor. The Renaissance changed the profession from a craft to an art that included the concept of individual originality. The artist became a scholar, accepted as fit company for princes.

14

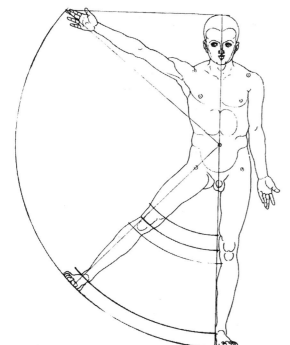

1.7 Albrecht Dürer, *Figure of Man Shown in Motion*, 1528. Sachische Landesbibliothek, Dresden.

Dürer's attempt to relate human proportions to an underlying universal harmony is typical of the Renaissance preoccupation with the idea that man is made in the image of God.

1.8 Leonardo da Vinci, *Skeleton of an Arm*, c. 1510. Royal Library, Windsor.

This drawing is one of a series by Leonardo describing the working of the human body. It clearly demonstrates the astonishing advances in scientific inquiry and understanding made during the Renaissance.

The role of drawing responded to these changing demands. Instead of being one of the craft skills needed to produce art, it became a vehicle for inquiry into the natural world and an independent means of expression. The Renaissance was really the start of drawing in modern terms. As in classical art, the ideal human figure became central to artistic endeavor. The belief that man is made in the image of God led to the perception that the proportions of the human figure must contain the key to a harmony underlying all natural phenomena. Albrecht Dürer (1471–1528) was one of the first artists in Northern Europe to respond to these new ideas emanating from Italy (**1.7**). Stemming from this fundamental belief, life drawing became one of drawing's most important preoccupations — in contrast to the Middle Ages when the nude was associated with original sin.

The new-found interest in science and the human body encouraged the study of anatomy; strangely, this was led as much by artists as by doctors. Both Michelangelo and Leonardo da Vinci (1452–1519) dissected and drew bodies, which produced a new kind of drawing concerned with a precise description of nature (**1.8**). This desire to accurately record the world was also transformed by a successful theory of perspective being developed through a combination of geometry and drawing. For nearly 2,000 years, from the Greek painter of stage scenery, Agatharchus, in about 460 B.C.E. to artists such as Giotto (c. 1266–1337) in Italy, forms of empirical perspective had been used. But it was not until the artist and sculptor Filippo Brunelleschi (1377–1446) demonstrated the use of linear perspective in about 1413 that a reliable system came into existence. For the first time artists had the ability to create a convincing representation of space and illusion of reality. The first known written description of perspective is by Leon Battista Alberti (1404–72) in his book *Della Pittura* dedicated to Brunelleschi. As the Latin origin of the word "perspective," to see through, implies, it allowed the contemporary observer to imagine he was looking through a window at the real world.

Drawing also became a tool for design and experiment. Alberti described the new position: "If you want to paint a history painting … we shall make detailed studies and designs of the whole composition." He thus postulated an individual approach to composition and the study of details by drawing, implying observations directly from nature. Alberti also suggested that the painter "First draw the figure nude, then show it dressed," when designing a figure composition.

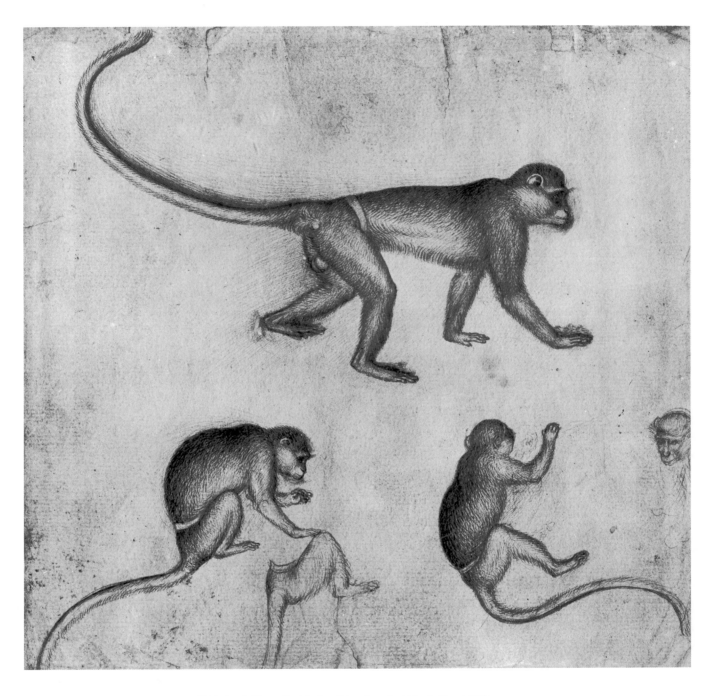

1.9 Antonio Pisanello, *Monkey*. Taken from the Vallardi Album, 15th century. Musée du Louvre, Paris.

These beautifully observed studies of a monkey in one of Pisanello's sketchbooks are dramatically different from the animals in a Villard de Honnecourt copybook. Pisanello is not working to a formula, but has totally embraced the new-found sense of inquiry central to Renaissance thinking.

The final change in the emancipation of drawing in the Renaissance was the acceptance of the rapid drawing or sketch as a valid form of drawing. The drawings of Pisanello (c. 1395–c. 1455) are a good example of the transition from the medieval pattern book to the modern idea of a sketchbook (**1.9**). By 1550 Giorgio Vasari (1511–74) was describing a sketch as a drawing "rapidly put on paper in a state of creative fury." It is difficult to imagine a medieval monk approaching his illuminated manuscript in a similar state of mind. Eventually the first preparatory drawings were appreciated and accepted more and more, until according to Eugène Delacroix (1798–1863) only the first flash of the idea is pure expression, "truth issuing from the soul."

THE ACADEMIES AND AFTER

With art now considered as a creation of the imagination and intellect, rather than a craft, the status of the artist changed. The old apprenticeship route was considered to be inappropriate, and a different and more intellectual method of training was devised. This was the academy, based on Plato's Academy in ancient Greece. Initially, such academies were free associations of philosophers, writers, and poets, as well as artists; Botticelli (1444–1510), Michelangelo, Titian (c. 1490–1576), and Palladio (1508–80) were all members of academies. By the mid-sixteenth century their nature changed, and they became less informal, with rules and courses of study in specialized areas. In 1562, in Florence, Vasari organized the first academy specializing in art. The aim was to teach theoretical subjects such as anatomy, perspective, and proportion, more in keeping with the artists' new intellectual status. The new awareness of a drawing's potential meant that it was the only practical subject taught. Painting and sculpture were matters taught by an experienced master in his studio.

The drawing course in the academy followed three rigid phases. The student first made copies of other artists' drawings to acquire practical skills. The second stage was drawing from plaster casts of classical sculptures, and finally the advanced student was allowed into the life room. The whole process was designed to give a student the essential ability of drawing the human figure, which was fundamental to the production of elaborate paintings, usually depicting many figures in complex composition (**1.10**). Mastery of the human figure was the key to being a successful artist both in the Renaissance and in the neoclassical period that followed.

The climax of the academic movement was the Paris Academy founded in 1648. Not only did drawings of the figure have to conform to prescribed ideals of proportion but even facial expressions portraying different emotions had a predetermined formula. The Academy had rooms in the Louvre, and

1.10 Michelangelo Buonarroti, *A Battle Scene*, 1500–55. The Ashmolean Museum, Oxford.

Michelangelo would have started his design by making a simple outline drawing, partly still to be seen on the left. He would then have worked up the idea and made it more three-dimensional by hatching in tonal areas.

Louis XIV vested absolute artistic authority in the Academy — so much so that for a time many artists in France became little more than civil servants. By 1700 over 100 academies existed all over Europe. But by the end of the century progressive artists felt that the academies' power and teaching methods were restrictive and that they were unable to fulfill the more personal ambitions of the emerging Romantic movement. A system that had helped to liberate the artist 200 years earlier was now perceived to be as reactionary as the medieval guilds. The artist as an individual genius and the idea of art for art's sake were finally established. The status of drawing had changed once again; now drawings were collected as works of art in their own right, partly because of their perceived closeness to the artist's most personal intentions.

The divergent views of art in the nineteenth century are encapsulated in the stances of two artists, Jean-Auguste-Dominique Ingres (1780–1867) and Gustave Courbet (1819–77). Throughout the century the academies continued to teach drawing in exactly the same way as they had always

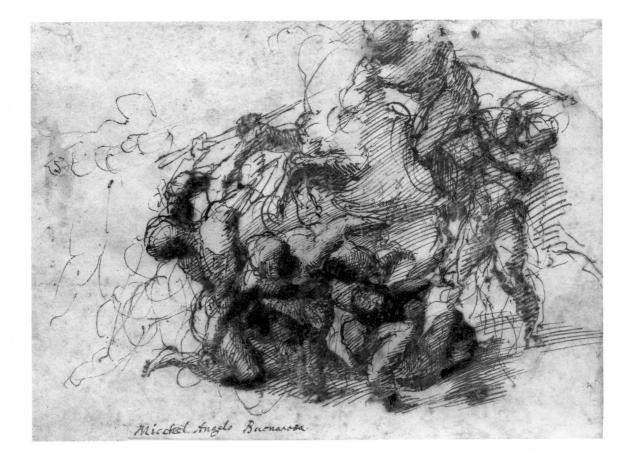

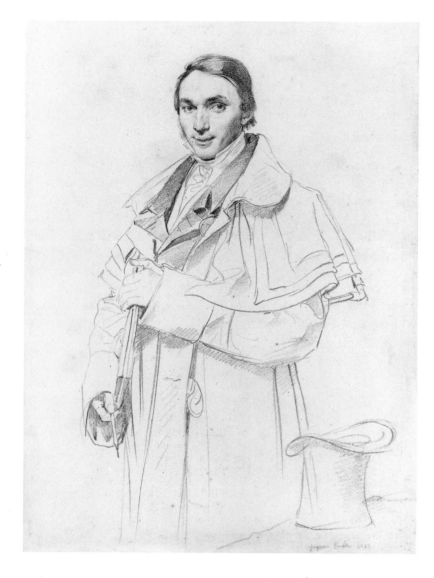

1.11 Jean-Auguste-Dominique Ingres, *Jean-François-Antoine Forest*, 1823. The Ashmolean Museum, Oxford.

Ingres staunchly supported the academies' traditional methods of teaching drawing. His refined and subtle drawings are fine examples of the neoclassical view of drawing, dating back to the Renaissance and Ingres' hero, Raphael.

done, and were supported by artists like Ingres, whose refined technique exemplifies the best of the academic tradition (**1.11**). At the other extreme, the champion of realism, Courbet, was suggesting that art schools of any kind were superfluous, although being self-taught, he was perhaps not a totally neutral witness (**1.12**). Courbet also diverged from the academies' methods by rarely using drawing as a major preparation for a painting.

This conflict of ideas encouraged the range of drawing to multiply, as did teaching methods. Students again went to individual artists' studios for drawing lessons, and different types of art schools became established. Many of these new art schools broadened their courses to include crafts and design, as well as fine art. However, the methods of teaching were often still geared to a rigid training, and drawing classes bore a striking similarity to the academies' cast-room methods (**1.13**). For example, the Royal College of Art in London was established in 1837 as the British Art Training School, with a specific mandate to improve the quality of design in industrial manufacturing. The courses were very disciplined and structured; a medieval apprentice would not have felt entirely out of place.

These changes were occurring on both sides of the Atlantic, and the experiences of two artists is illuminating. Egon Schiele (1890–1918) was a student at the Vienna Academy of Fine Art from 1906 to 1909. The course of study, started in 1720, had not changed and the collection of 1,650 plaster casts was in daily use. The Academy, however, was on the defensive and was deeply concerned at the influence Gustav Klimt (1862–1918) and the Vienna Secession were having on the students (**1.14**). Schiele, with the support of other talented students, drew up a 13-point demand for reform. Unsurprisingly, they were unsuccessful; they were thrown out of the Academy, and they formed instead the *Neukunstgruppe* (New Art Group), with views more in keeping with Klimt and the Secessionists.

1.12 Gustave Courbet,
*A Young Boy Holding a Basket of
Stones*, 1865. The Ashmolean
Museum, Oxford.

In contrast to Ingres, Courbet
strongly disapproved of the
academies and their neoclassical
ideals. Not only did he draw in
a more direct way with far less
emphasis on clearly defined
outlines, but his subject matter
was far more egalitarian. Ingres
would never have drawn a
working boy.

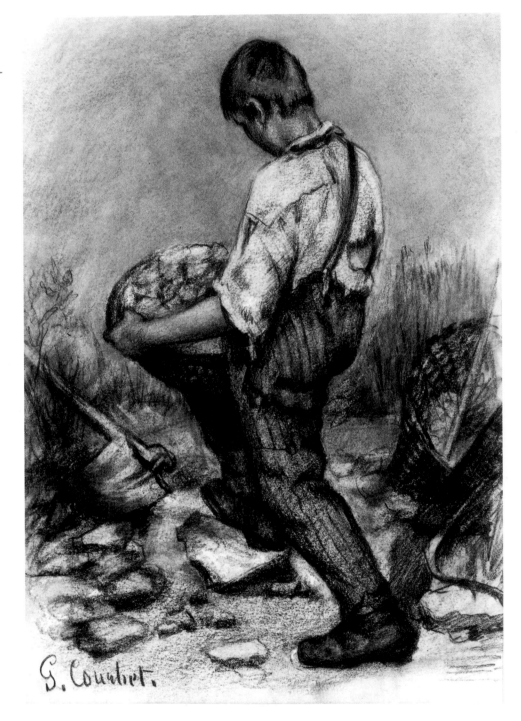

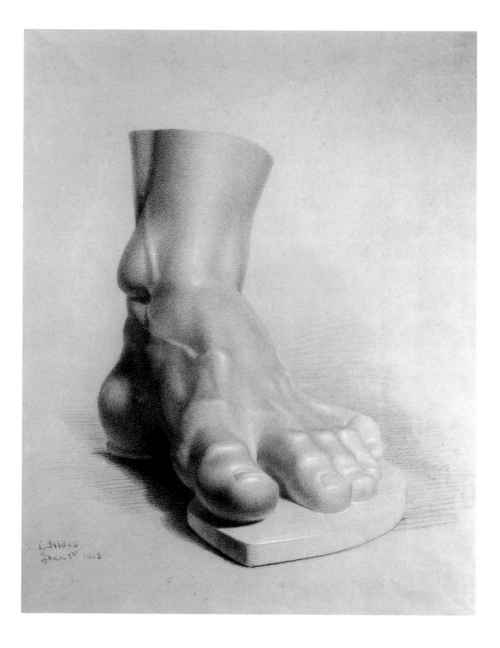

1.13 Luke Fildes, *Study of a Plaster-cast Foot*. 1863.
The Victoria and Albert Museum, London.

Fildes produced this drawing in 1863 when he was a student
at the British Art Training School. Although originally established
to improve the quality of design, the syllabus at the school soon
became similar to those of the academies and again included
cast drawing.

22

1.14 Egon Schiele, *Self-portrait*, 1911.
Private collection.

This intensely observed self-portrait, more concerned with psychology than form, indicates the gulf between the ideas of the academies and the Secessionists. The exaggerated pose and the strangely proportioned figure, extending beyond the edge of the paper, would have been abhorrent to academic ideals. The basic reasons for making a drawing had totally changed

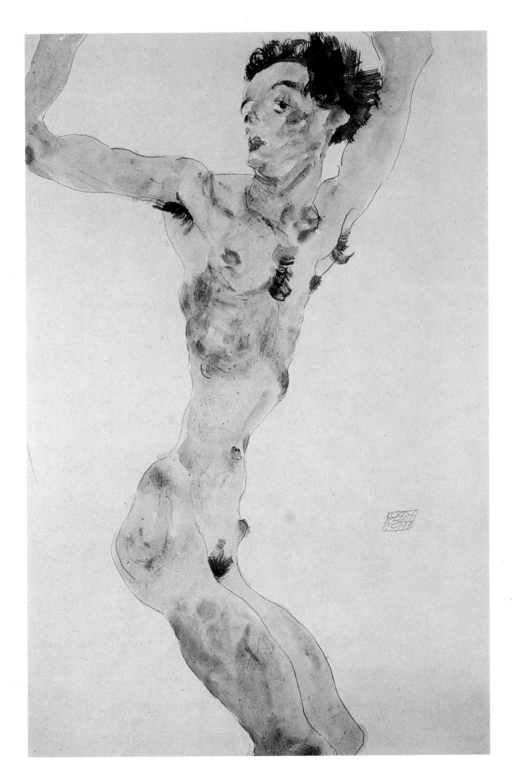

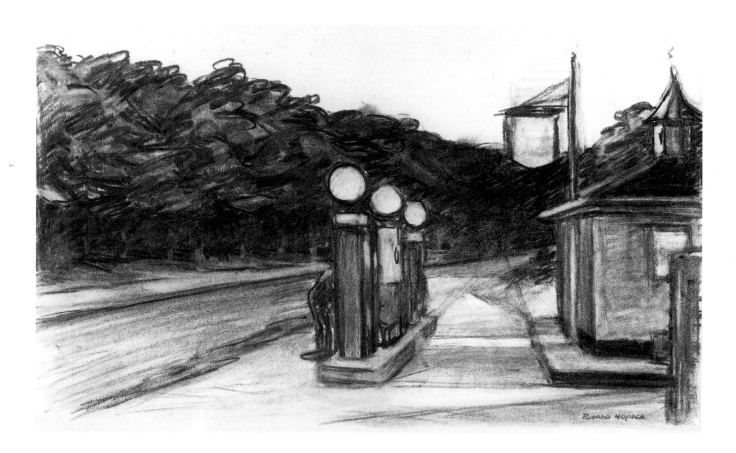

1.15 Edward Hopper, *Study for the painting Gas*, 1940. Josephine N. Hopper Bequest. The Whitney Museum of American Art, New York.

In this drawing Hopper manages to create a feeling of still melancholy that is typical of much of his work. Hopper's interests centered on contemporary life, and a gas station was a naturally mundane subject for his attention. However, the ordinariness is transformed by the strange light effect created by extreme tonal contrasts, little modified by the use of half-tones.

In America Edward Hopper (1882–1967), the supreme observer of the everyday scene (**1.15**), had nearly a reverse experience, perhaps benefiting less from new teaching methods. In 1900 he enrolled on the illustration course at the New York Art School before later studying painting. Robert Henri (1865–1929), a young realist painter of New York life, was one of the more influential and dynamic teachers bringing new ideas to art education. Hopper responded enthusiastically and was greatly influenced by Henri. However, in later years he was critical of the teaching because of a lack of attention to fundamentals of design and technique, saying, "It took me about ten years to get over Henri."

By the end of the nineteenth century a revolution as considerable as the Renaissance was taking place, fueled by a mass of new ideas and inventions. Psychology, photography, new political theories, the mass reproduction of images, the awareness of totally different artistic traditions, the idea of the noble savage and lost innocence — the list is endless, and art responded with

a multitude of new permutations. Although academic principles proved extremely resilient, surviving well into the twentieth century, their decline was now terminal. The art school that we would recognize today was beginning to emerge and one of the most influential was the Bauhaus, established in 1919 in Germany by Walter Gropius (1883–1969). He was partly inspired by the left-wing views of William Morris (1834–96) and the Art and Crafts movement with the desire to unite the artist and the designer/craftsman. The wheel had in some ways turned full circle after 500 years. Drawing was part of the curriculum at the Bauhaus but not as the academies would have understood it. For example, Wassily Kandinsky (1886–1944) held "analytical drawing" classes and wrote: "Drawing instruction is a training towards perception, exact observation and exact presentation not of the outward appearances of an object, but its constructive elements, its lawful forces — tensions." The Bauhaus was forced to close in 1933 when the Nazi party took control of Germany, but its influence continued. Courses dealing with fundamental visual principles that apply to both fine art and design students are the Bauhaus's continuing legacy.

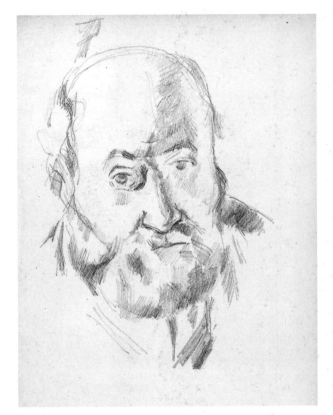

1.16 Paul Cézanne, *Self-portrait*, 1888. The Art Institute of Chicago.

Cézanne makes no attempt to produce pencil marks that imitate appearance. The marks are evidence of his efforts to discover the structure of his face. He probably started with the eyes and nose, then slowly worked round the form until he reached the edge of his head. Because of this method of working there is little effort made to delineate an outline.

The availability of drawing paper in the fifteenth century allowed drawing to develop; this was mirrored in the late nineteenth century when it became possible to manufacture much larger sheets of paper. There was now hardly any limit on the possible size of a drawing. The way materials were used also changed, initially by the Impressionists, but particularly by artists like Vincent Van Gogh (1853–90), Paul Cézanne (1839–1906), and Georges Seurat (1859–1891). They used marks that became as much part of the subject of the drawing as the object being described; a process seen in a self-portrait by Cézanne (**1.16**). As the twentieth century progressed, the re-evaluation of marks and traces of the drawing process continued and they eventually became the sole justification of some non-figurative drawing. By the middle of the century the mark became art for some artists such as Franz Kline (1910–62) (**1.17**). Drawing in the twenty-first century can be produced in any media, at any size, and be about any subject, and with a computer not even paper is required.

This selective and incomplete survey of drawing's past is certainly not intended as an art history lesson. It is an attempt to give examples and a flavour of the different milieus in which drawings have been produced. Looking at drawings

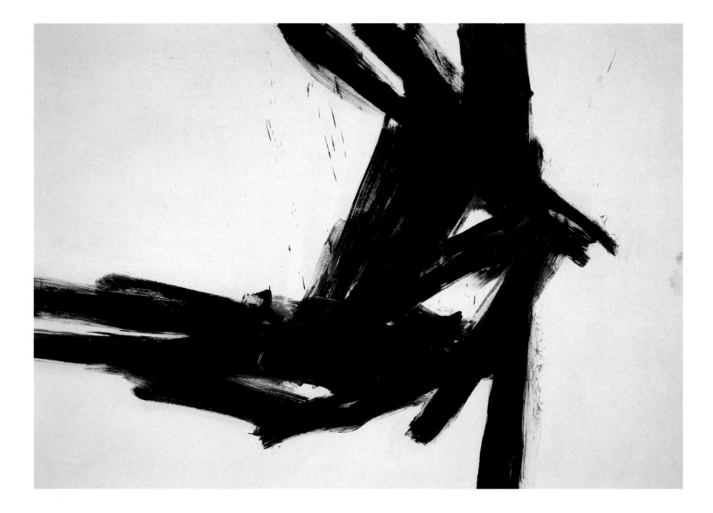

1.17 Franz Kline, *Corinthian II*, 1961. © Museum of Fine Arts, Houston Texas. Bequest of Caroline Weiss Law.

In this large painting, Kline's gigantic brushstrokes display an amazing confidence and gestural vitality. Both in his small-scale drawings on paper and in his large-scale paintings, Kline adopts a very similar approach to his mark making.

is always more illuminating if they are seen in the context of their times, together with our contemporary expectations. Having no awareness of the past is like an individual suffering from loss of memory. One surprise from this survey is that drawings of the highest quality have been produced in circumstances that seem most unpropitious for the production of great art. Another lesson is that artists have often found working within or reacting against some definite schema or convention was helpful and stimulating, rather than limiting. Total freedom of expression can even be inhibiting rather than emancipating for some artists.

In the twenty-first century the reasons for drawing are more disparate than ever and the dogmas from the past no longer seem tenable. However, the corollary of this is not that there are no principles or concepts relevant to learning how to draw today. In reality there are many fundamental ideas that can be of invaluable assistance and they are the subject of the rest of this book.

Ideas to Explore Analyzing masters' drawings

THIS chapter has been about the amazingly diverse use artists have made of drawing over the years. Most books on artists and designers, understandably, concentrate on their finished work, often with only a few examples of their drawings being illustrated. This means it is quite difficult to have a clear and undistorted idea of how important drawing is for most artists.

To overcome this problem you will need to look in the specialist section on "Drawings" in the library or bookshop, as well as the more general books on individual artists. Try to become familiar with the drawings of as many artists and designers as possible. Looking carefully at drawings and seeing how they are made and selected is particularly helpful, and gives important clues about the drawing process.

Select two or three drawings that you find particularly stimulating and try to analyze why this is. It may be the subject matter, but also comment on the way the artist has selected what to draw and the way materials and marks have been used. If you make a copy of a drawing, it is surprising how much more you will understand about it than by just looking. You will really begin to appreciate how subtle and varied the marks are that contribute to a fine drawing.

2

Reasons for Drawing

EVERYBODY approves of goodness. In the art world everybody approves of drawing, but it is surprising how, like goodness, it is hard to define. When a definition is proposed, alternatives and caveats are always produced. If an agreed definition is difficult, then at least it is possible to list some of the things drawing can do and by extension who might benefit from being able to draw.

The most fundamental reason why drawing is so prized is that, compared with every other visual activity, it can be produced with the most basic of materials, it is totally flexible, and it can be rapidly made and easily amended (**2.1**). This means that it is the perfect tool for the artist and designer to express, refine, and communicate their most personal thoughts and ideas. The American artist Saul Steinberg (1914–99) expressed it very simply: "Drawing is a way of reasoning on paper."

As well as letting ideas out, drawing is the ideal method of getting ideas in. It is unparalleled as a way of recording information and acquiring understanding that will provide the artist with a visual vocabulary of forms, structures, images, and ideas for use in the future. Drawing allows the artist to become fully visually literate.

2.1 Keith Micklewright, *Garden*, 1990. Collection of artist.

Over a relatively short period of time and with only a pencil, I was able to explore and describe a quite complex situation. It could not have been done so concisely in any way other than drawing. The pencil, in particular, allows a vast range of marks to be made, from very dark and broad to extremely soft and delicate.

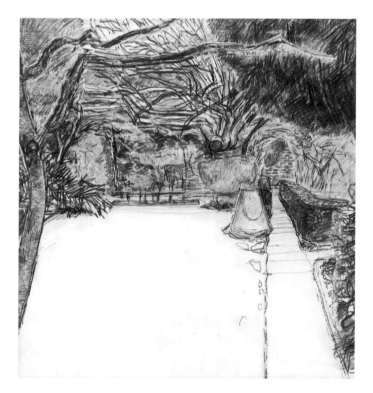

Because drawing is so flexible it is ideal for analyzing problems, generating ideas, and resolving difficulties — in other words, designing. Drawing really can be the midwife of the imagination. Each transient idea can be captured, and this allows a series of mutations and cross-fertilizations to occur and develop.

The appearance of the real world is constrained by natural laws, but drawing allows the imagination to remove reality's constraints. Visual fantasies can be drawn so they appear totally convincing. Ideas that normally remain stranded in one's head are made real and visible by drawing. The scene that Hogarth has described (**2.2**) is impossible, but drawing has freed his imagination to make the impossible real.

The physical process of making marks while drawing, combined with an experimental use of materials, can in its own right produce images and effects full of potential for the artist. Drawings are produced in time and grow organically. They are consequently

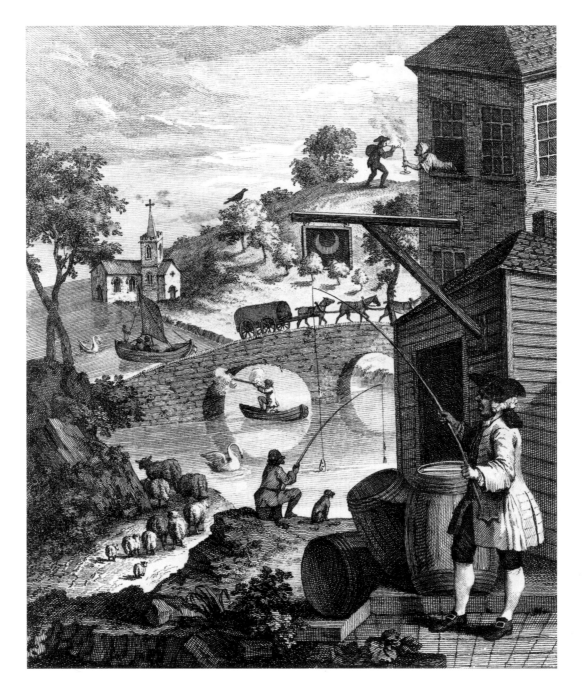

2.2 William Hogarth, *The Fisherman or False Perspective*, 1753. British Museum, London.

At first glance Hogarth's engraving looks perfectly normal, but then we notice that little in fact makes visual sense. All the perspective is wrong, the near fisherman is fishing in a distant river, the man on the hill lights his pipe from the old lady's candle, the sign is behind the trees on the far hill and they increase in size instead of vanishing, both ends of the church are also visible. Much else is wrong in Hogarth's impossible world that only drawing could create.

particularly adept at exploring and recording temporal activities such as movement, change, accumulation, and metamorphosis. Special demands and activities have developed drawing into distinctive and personal idioms. Illustrators, fashion designers, filmmakers, textile designers, architects, and engineers have all adapted drawing to their own particular needs, using it to capture first concepts (**2.3**) or to develop ideas. Finally, a major justification for drawing over the centuries has been its use as a visual discipline. Being able to see and draw accurately, subtly, dynamically, expressively, and meaningfully, has been an expectation that most artists accept as being important, even if not always fully achieved.

DRAWING AND SELF-EXPRESSION

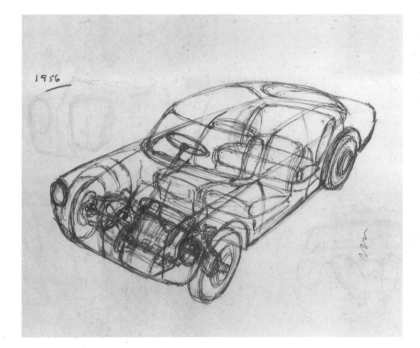

2.3 Sir Alec Issigonis, First Concept of Front-wheel Drive, Transverse-engine Vehicle. 1956. Collection of Designer.

Issigonis was the designer of the "Mini" which was developed from the ideas in this drawing. He said, "The engineer who cannot draw cannot communicate his thinking to his colleagues and to those who have to translate his ideas into practical reality."

Because drawing is one of the most personal and immediate forms of self-expression, it is sometimes suggested that nothing should be done to corrupt this path to the outside world. The Victorian author and critic John Ruskin (1819–1900) talks approvingly of the innocence of the eye, which could be qualified as a sort of childish perception, a blind man suddenly being able to see, or the banishment of experience. Unfortunately the blind man, given sight, would not suddenly see, but like all human beings would have to learn to see and acquire a "corrupting" visual memory that would compromise his eyes' innocence. The child's simplified and innocent view of the world inevitably changes with age and if not superseded with knowledge is usually replaced by a knowing naiveté. Spontaneity should not be confused with innocence, and knowledge should not be seen as corrupting, but liberating. Nobody would tell an author that learning to read and write would compromise the imagination or advise a musician to cherish incompetence. John Constable (1776–1837) was near the mark when he said, "The artist who is self-taught is taught by a very ignorant person indeed." The obvious exceptions of artists like Henri "Le Douanier" Rousseau (1844–1910), Alfred Wallis (1855–1942), or Morris Hirschfield (1872–1946) (**2.4**) prove the rule. You cannot learn, or even unlearn, to work like them; it is impossible to choose to be a primitive artist, it just happens.

Of course, in reality most people accept that information and knowledge assist

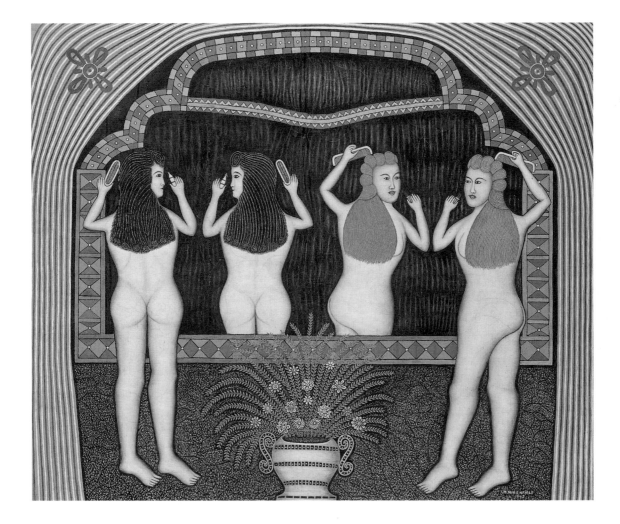

2.4 Morris Hirschfield, *Two Women in Front of a Mirror*, 1943.
Peggy Guggenheim Foundation, Venice.

This intriguing work has echoes of Egyptian art, with its lack
of depth and frieze-like structure. Hirschfield obviously found the
problem of representing a reflection in a mirror difficult and
resorted to just reversing his image of the two women. This is
the unique vision of a primitive artist, and this painting is a
quintessential example of an art that cannot, by its very nature,
be taught.

creativity and broaden the means of expression. Learning about all aspects of drawing is essential if an artist is to have access to a full visual vocabulary and not feel inhibited by a lack of means to express ideas.

Learning to draw is a bit like the chicken and egg conundrum. Without being able to "see" it is difficult to draw, but without being able to draw it is a problem learning to see. Fortunately, the two activities are not mutually exclusive, and the process of learning to draw deals with both concurrently. An initial and more formidable phenomenon is how often people need persuading that the ability to recognize objects is not really seeing. A student of James Whistler (1834–1903) claimed she only painted what she saw. He replied, "But the shock will come when you see what you paint."

Ideas to Explore Establishing the creative impulse

HAVING a reason for making a drawing is obviously fundamental, but as we have seen in this chapter it can be quite hard to establish clearly a personal reason for drawing. So as well as using drawing initially to learn to see and discover and understand the visual world, it is also helpful to be aware of how it has been adapted for particular needs and interests.

Drawings often relate to an artist's more personal interest in a particular area of activity. Spend some more time looking at drawings, but on this occasion try and find drawings that perhaps relate more to your own personal ambitions. You may be more interested in sculpture than painting, so see if you think there is such a thing as a "sculptor's" way of drawing, or is this a totally false idea? Photography is possibly your future, so is there any value in learning how to draw when the camera will already produce perfectly satisfactory images?

Do you always draw in a similar way, at a similar speed and with the same materials? If you do, does this inhibit you from drawing certain ideas or situations? Make a list of things you would find difficult to draw and why. Now attempt to draw these unfamiliar ideas and things, perhaps by changing media, using different types of marks, drawing quicker or slower, larger or smaller, but perhaps most importantly changing the way you think.

Visual Thinking and Visual Language

I T is obviously possible to draw without knowing how our eyes work, but certain aspects of the visual process do have a relevance to drawing. Since the invention of photography there has been a tendency to compare vision to the photographic process. While there are some similarities, they are in fact very different; there is no single image created in our brain that is the equivalent of a photograph. Another obvious difference is that our vision is a moving picture, so a video camera perhaps is a more useful analogy, but even this bears little relationship to how the eye and brain work.

The eye has two main parts (**3.1**): the lens, which allows focused light into the eye, and the retina, which receives the light, collecting the information for transmission to the brain. The retina has millions of light receptors; these are divided into cones that register color and rods that respond to tonal values. The information collected in the eyes is sent via the optic nerve to the visual cortex in the brain.

The cortex has about one million cells, some organized in a similar configuration to those in the retina, but how exactly the patterns recorded by the retina become sight is only partly understood. Some cells in the cortex have single functions such as responding to brightness or color orientation at particular points in the observed scene, while others are combining and filtering the information. How the confused patterns that emerge are translated into objects is similar to the problem of deciphering a continuous stream of sound into individual words. Cells with a memory recognize the "edges" of each word's sound as we talk, although the sound is hardly physically separated. Similarly, there are visual cells with a stored memory that distinguish between the random patterns and recognizable groupings that have distinct boundaries. This allows the brain to identify the remembered object and its name. To a very large extent we only see what we have learnt to know.

The cells in our brain are continually filtering, adjusting, and merging new information as it comes from our eyes. Strangely, although we see movement and change while we observe a particular situation, the brain does not record the blur of movement that would occur as our eyes scan to another image. The eye does not respond during saccadic movement, only registering the next image when the eyes come to rest. An important result of this is we only see straight lines as straight lines, not as the curves that would be produced by moving eyes continuously changing the angle of vision along the lines' length.

The similarity between the way a drawing is produced and the way vision works is striking. The accumulation of information over a period of time is the

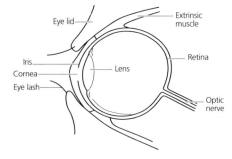

Eye lid — Extrinsic muscle

Iris — Retina

Cornea — Lens

Eye lash — Optic nerve

3.1 Parts of the Eye

Because the eye focuses light through a lens onto light-sensitive nerve endings in the retina at the back of the eye, the visual process is sometimes compared to the way a camera works. However, the way the brain converts and processes the information received from the retina via the optic nerve bears little relationship to photography. The processes of making a drawing and a photograph are totally different.

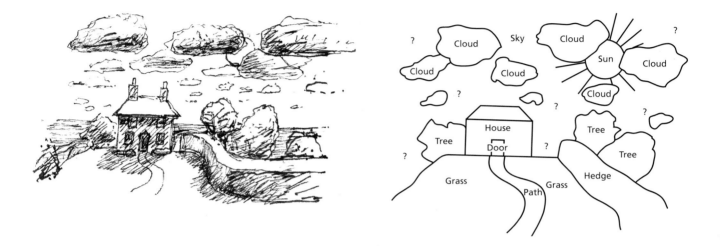

3.2 Words and Vision

We think in words, and when we look at the world the brain changes what we see into words. The parts of the image that have no verbal equivalent are therefore not "seen" or valued. This means that much of the information needed to make a drawing is unavailable.

essence of both activities, but the automatic assumptions that largely control our way of seeing are also one of the main problems when learning to draw. Drawing requires that we are able to see in a way that does not assume we already know the answer.

THINKING VERBALLY

Learning to talk and then read and write dominates our early education. We learn to think in words, so the brain automatically changes every object seen into a word. It is impossible to look at anything without a word or cipher forming in our brain.

This process reinforces the brain's eagerness to search for familiar named objects and encourages us to recognize the world without seeing it accurately. Everyday existence would be impossible if we were surprised every time we looked at something and it seemed new. If we could not recognize a moving car immediately, life in the streets would be very short. Assumptions and presumptions are therefore made all the time, but they stop us really seeing.

Another consequence of verbal thinking is that shapes that are between objects often do not have an equivalent in words and are therefore not "seen" or valued, as shown in the diagrammatic representation of the sketch of a cottage in a landscape (**3.2**). These shapes are ignored by the brain and much of the visual information needed to produce a drawing is rendered unavailable.

3.3 Order and Meaning

As the order of letters produces words and meaning, so the same applies to marks: their relationship is more important than the individual marks in a drawing.

reordered becomes

We can think and survive quite easily without needing to really understand the visual world. Failure to learn to read and write keeps us illiterate; without learning to "see" we remain visually illiterate and unable to draw.

THINKING VISUALLY

To be able to draw, the brain must be taught to see and give equal importance to shapes, positions, directions, and all other visual relationships, rather than only recognize objects and change them into words. In effect, to think visually, not verbally. To make a drawing the answer from each observation must be a visual relationship or quality of some kind that can be translated into a mark. The word "hand" contains no information that can contribute to a drawing. Drawing is a different language, with a different vocabulary, so a dictionary is of little help when learning to draw.

Languages, both visual and verbal, rely on order and relationships to give meaning. If the combinations or positions change, so does the meaning; thus DOG slightly reordered becomes GOD, and diagram **3.3** shows the potential of four lines to be rearranged as square. Less drastic changes, such as punctuation, or stress in speech, can also have a radical effect.

A position can only be assessed and have meaning if other positions exist. A dot marked "New York" (● New York) gives no idea of the city's position. New York's location only becomes apparent when other places and features are indicated and considered in relation to it (**3.4**).

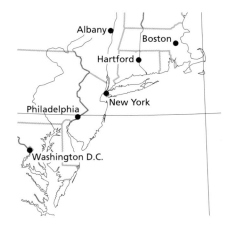

3.4 Relationship and Meaning

New York's position can only be assessed if the positions of other cities are represented. A drawing is the same: it is the relationship of the parts, not the individual parts, that allow it to work and be understood.

Basic Visual Vocabulary

DOT ● = Position	A series of dots can be similar to a line and become directional.	
LINE = Length / Direction / Angle / Division	Conventionally, a line indicates contour. In fact, few lines exist in nature. Abutting areas produce edges, often corresponding to objects, and these are translated into linear equivalents by artistic convention.	
SHAPE = Two-dimensional area	A shape is defined by a boundary line or a tonal or color distinction from the surrounding area. Shapes leave and create other shapes. These can be positive/negative or figure/ground distinctions.	
FORM = Three-dimensional volume	Forms are revealed by the external planes/surfaces that enclose their internal volume. It can be drawn by the use of illusion or some type of drawing system.	Perspective Horizontal oblique
SPACE = The volume in which objects exist	Space cannot be drawn, but is implied by describing objects and surfaces that exist in it. The effect of atmosphere (aerial perspective) can also help to describe distance.	

Similarly in a drawing, comparing the relationships of a series of marks, not single marks, will produce visual "sentences" or structure. Before discussing the actual process of drawing, it is important to establish a few basic definitions. The table of Basic Visual Vocabulary on the previous page introduces five essential components of basic visual vocabulary which will be discussed in greater detail throughout the book. It is important, however, to have their meaning and role clearly defined from the beginning.

Unlike words, which relate sequentially, visual "sentences" obviously have a less rigid two-dimensional structure, so the analogy with words becomes less relevant beyond a certain point. However, the fundamental premise remains, that the ability to imaginatively combine individual words, notes or marks into a satisfying whole is a basic requirement in the making of any art form, including drawing.

Ideas to Explore Keeping a visual notebook

LEARNING to draw is more to do with thinking in a new way than anything else. The most difficult problem is trying to stop the brain changing everything we see into words. Words are wonderful, but they have little connection with drawing and learning to really see. Try and cultivate this different way of seeing and thinking all the time, not just when making a drawing. Get into the habit of asking more visual questions about the world than just the minimum required for basic recognition and survival. Practice drawing in your head by noting proportions, angles, and relationships. It will then become the natural way of looking, not something you have to remember to do at special times in a drawing class. You only become really fluent in a foreign language when you begin to think in that language. It is the same with drawing; you only begin to draw fluently when you automatically think visually.

However, just looking or thinking about something is obviously totally different from the visual rigor imposed by producing a drawing. Acquiring a drawing habit is as important as regular practice when learning to play a musical instrument. Having a sketchbook readily available makes it possible to draw on demand and encourages a drawing habit. It is depressing how many good ideas fade into oblivion if they are not immediately noted down in a drawing. I prefer the term "drawing book" or "visual notebook," as the word "sketch" seems to imply something less considered and lightweight. This does not mean that these drawings are highly elaborate, but it does mean they are considered, however quickly they are made.

Samuel Palmer, *Page from the artists' notebook*. Ashmolean Museum, Oxford

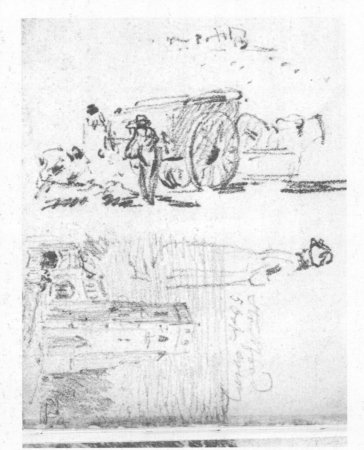

The intention will dictate the time taken and final appearance of the drawing, not some pre-determined formula of how to produce a "sketch." The drawing book can be any size that seems right for the individual; having more than one size to suit various situations is a good idea. The main thing is to make it possible to draw easily and regularly. The unselfconscious immediacy of the two pages by Constable and Palmer are characteristic of the drawings found in artists' notebooks. They are usually freely, but thoughtfully drawn, and show the artist trying to record or resolve a particular visual concern and interest. Constable often used quite small books; this page is only 2½ x 3½ in, but it contains three drawings, although one is partly on top of another. Palmer's page is totally covered with notes and observations drawn with an obsessive directness and confidence. Such drawing books are all very personal; for example, Pierre Bonnard (1867–1947) often used a diary as his notebook, and as well as making a drawing he would also record each day's weather in one or two words.

4

Learning to See and Draw

WHAT physically is a drawing? In practical terms it is the surface that is the equivalent of a transparent imaginary surface placed between the observer and the object being drawn. This imaginary surface is called the picture plane and is the surface on which judgments and decisions are made before transferring them onto the real drawing. The size of the drawing will depend on where this imaginary picture plane is positioned (**4.1**). Placed near the object, it produces a large image, near the eye a smaller image. The picture plane is often imagined at about arm's length or the same distance as the actual drawing surface from the eye. This means that the imagined picture plane and the drawing are the same size, which obviously simplifies the drawing process. This relationship is sometimes called "sight size" and allows measurements to be taken at arm's length from the eye that are the same size as the drawing.

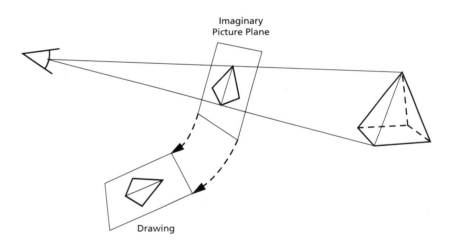

Imaginary
Picture Plane

Drawing

4.1 Picture Plane

A picture plane is the imagined surface placed between the eye and the subject matter of the drawing. Decisions are made on this imagined surface, before they are transferred onto its real equivalent, the drawing. Where the picture plane is imagined will dictate the size of the drawing. A small drawing will have a near picture plane and the drawing increases in size the further away the picture plane is imagined. If it is imagined touching the object, a drawing the same size as the object is produced.

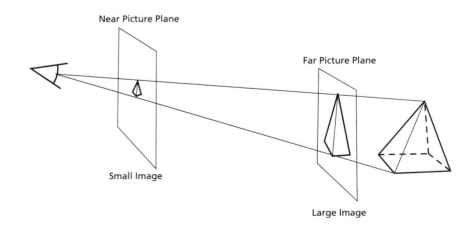

Near Picture Plane

Far Picture Plane

Small Image

Large Image

4.2 Framing

To help identify an imagined picture plane an adjustable frame made from two L-shaped pieces of card can be used, rather like a camera's view-finder, framing the subject matter of the drawing. The two cards can be adjusted to make any shaped rectangle and therefore help in the design of the drawing.

Because we usually draw on a rectangular piece of paper the picture plane is also identified as a similar rectangle. To help identify this imaginary picture plane, a "frame," made from two L-shaped pieces of card, can be held rather like a view-finder framing the subject matter of the drawing (**4.2**).

Another advantage of having a rectangular picture plane is that the drawing is constrained by vertical and horizontal edges. This means that the horizontal edges of the paper are identical to the horizontals in the situation being drawn, making the judgment of angles easier.

LOOKING ...

Before starting a drawing we have to look. Looking usually implies observing some external object, but it also applies to imagined situations. The process of drawing an idea is just the same as drawing an object. They both have to be "looked" at and translated into marks with the same awareness and invention.

Unlike Van Gogh (**4.3**), Giorgio De Chirico (1888–1978) (**4.4**) obviously was not sitting in front of the objects in his drawing, but he has translated his idea with equal intensity. He looked just as hard at his imagined landscape as Van Gogh looked at his real place.

To avoid confusion and make explanations easier, most of this book is concerned with the process of observing a real situation or object, although the concepts equally apply to the problem of drawing imagined ideas.

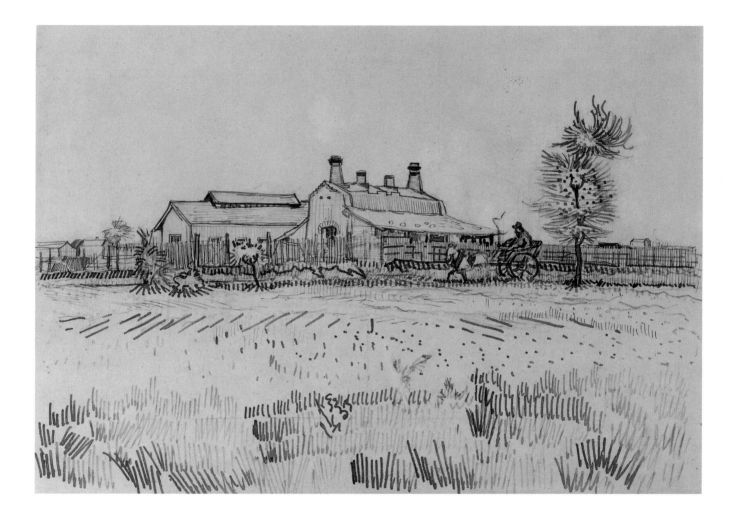

4.3 Vincent Van Gogh, *View of a Tile Works*, 1888. The Courtauld Institute, London.

Van Gogh was fascinated by the oddly shaped roof-line of the tile works standing out from the flat landscape of tufted grass. His visual imagination was triggered by his intense interest in looking at the world, even when the subject matter was at first glance mundane.

... AND COMPARING

Drawing is a language, and language has meaning through the relationship of its parts. Drawings are therefore not produced by imitating or copying isolated bits in a random and unrelated way. Learning to draw requires establishing a comparative way of looking, so that the relationship of positions, lengths, angles, tones, etc. are accurately assessed. We accumulate visual information from many observations, which are then organized, amalgamated, and understood. A drawing is made in the same way.

An important consideration when starting a drawing is one of scale. The relationship between how big we see something and how big it is drawn can be confusing; often a drawing is started and its size is established by chance. Everything is seen smaller than life-size because it is always seen at a distance. We know the real size of a person, bus, or hill so our brain is reluctant to believe just how small is the image our eyes receive. Making a tracing of a distant object

4.4 Giorgio De Chirico, *Solitude*, 1917.
Private Collection.

De Chirico's drawing, although not of a real place, has a surprisingly similar quality to Van Gogh's drawing of a tile works. It is not just the odd roof-line of the buildings, but it is the equally intense vision of a place created by looking — in this case by looking at the ideas in his head.

on a transparent sheet held at arm's length produces an unexpectedly small image. This is actually true "sight size" and is the most natural size to draw. This probably explains why most drawings throughout history have been relatively small. To draw larger or smaller than "sight size" requires that we consciously alter the scale of our observations to correspond to the size of the drawing.

A related consideration is which materials to use to make the drawing. Pencils and pens produce relatively small marks that are hard to increase in size, only in number. This can limit the potential size of the drawing. Conversely, charcoal is not good at making small delicate marks and needs a larger format to exploit its broader qualities. A very gestural drawing usually implies larger marks than a slower, more analytical study, so the size of the drawing needs to be appropriate for the medium. A similar question is how large does a drawing need to be to accommodate the artist's ideas and objectives. Big ideas do not always require big drawings.

We learn to read and write at the age of five or six, so a child's mental and

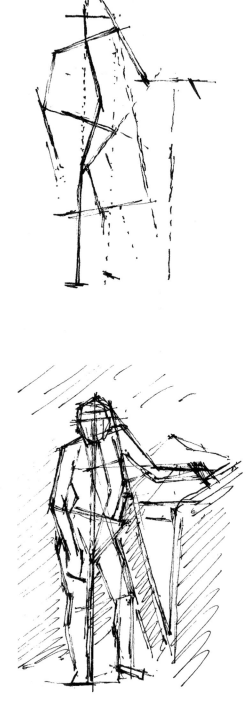

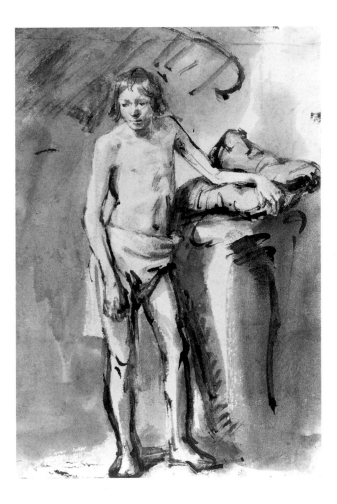

4.5 Rembrandt van Rijn, *Study of a Young Man Standing* and two diagrams analyzing the figure. Albertina Museum, Vienna.

These two diagrams by myself are not meant as a representation of the way Rembrandt physically made his drawing, but are indications of how he probably analyzed the figure to allow him to make his drawing. He would have been aware of the major vertical relationships before considering more detailed information.

linguistic abilities nearly correspond. As an adult, learning a new language always means that at first our intellectual demands far exceed our ability to express them. A similar problem arises when learning to draw: what interests us will be more sophisticated than our drawing ability. So when learning to draw the reason for a drawing need only be quite simple and visually basic. For example, can 30 or 40 positions and directions be related correctly? This probably means leaving out more of the possible content than in theory could be described. Deciding what a drawing is not about is nearly as important as selecting what is relevant.

ASKING BASIC QUESTIONS

Simple basic questions need to be asked at the start of a drawing. What shape is the object or idea? Is it tall/wide/square, vertical/horizontal/ angled? In other words, what is its basic design? If, for example, the drawing was of a standing human figure, it would be important to look at the head in relationship to the feet, not just the head in isolation. Think of the dot marked New York. Ask easy questions. Is something to the right, left or directly below something else? How do you get from the head to the feet in your drawing? Is it by a series of angles, and if so where do they occur? Get from the head to the feet by drawing a visual "sentence," not an unrelated and disjointed collection of details. Rembrandt's standing figure (**4.5**) is totally balanced, each part of the body rhythmically related to next, with the head perfectly positioned above the supporting foot.

It is important to think about proportions by comparing amounts. At first make two-dimensional judgments, widths compared to heights, as this is the basis of most proportions. Look for simple relationships which will have simple answers; these are then more likely to be correct. Is something the same as something else? Where is a half or a quarter of the total height? Always look at more than one thing and compare. Be greedy for visual information; consider lots of relationships, not just one or two, so that a matrix of related marks is developed. Make sure the answers are positions, lengths, angles, not words. The word "hand" is not the shape of a hand. Practice drawing in your head before you make the real marks. Look for similar lengths, angles, make visual "rhymes." If a line or direction is extended, where would it go to? For example, would the direction of an arm, if continued, lead to a knee or toe (**4.6**). Notice how positions and directions relate across the whole drawing, not just limited to the next part.

Many initial observations will be two-dimensional. However, most things that we draw are not just flat shapes, but have three-dimensional volume and exist

4.6 Comparative Looking

Looking at a large number of positions and comparing how they relate is the essence of how information needed to make a drawing is collected. The lines in this diagram show how relationships across the whole drawing should be noticed.

in a spatial environment. This means that in addition to assessing lengths and angles it is equally important to think about planes and volumes and how they relate in space.

An obvious example of three-dimensional thinking is observing how a group of objects relates to a floor or table top. The tables and chairs in a room have a number of related horizontal levels, all the legs will touch the floor, the seats will be roughly on the same plane above the floor. Therefore the chair seats should all be drawn at the same time, not as separate items. The chair legs will all have positions on the floor dictated by the common level surface, so by drawing these positions correctly the floor level will also be described (**4.7**).

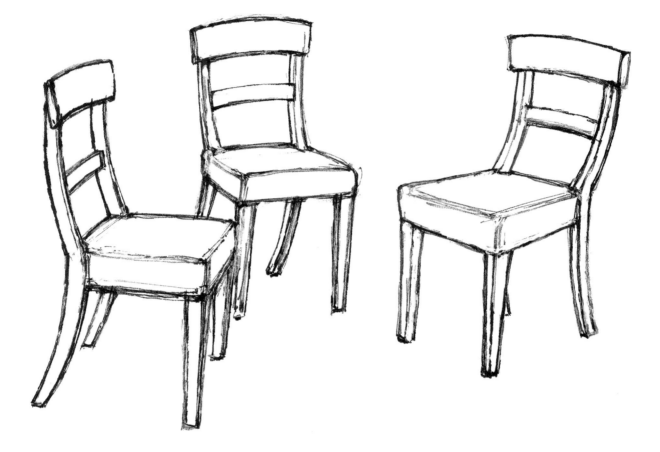

4.7 Three Chairs

The three chairs have been drawn without any surroundings, but by relating the chair legs carefully to one another the floor is still convincingly implied. The chair seats and backs are also thoughtfully related and describe common levels and volumes and are not just isolated and unrelated details.

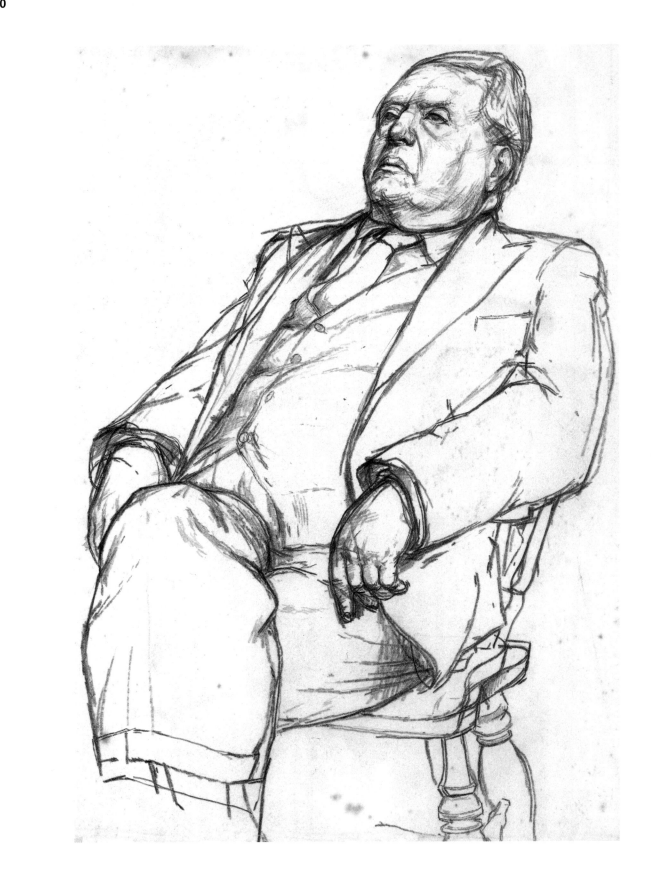

4.8 Keith Micklewright, *Seated Figure* and diagram for *Seated Figure*, 1970. Collection of artist.

Because the figure is leaning back in the chair he is creating a number of diagonal volumes in space. These should form the basis of the drawing's structural relationships, as well as a two-dimensional set of visual connections. The low eye level also accentuates the three-dimensional quality of the figure. There are several horizontal levels, such as the chair seat, the arms and knee, and the shoulders, which need to be considered together. I have used hair, folds, cuffs, buttons, etc. to imply the three-dimensional volumes underneath. The dotted lines in the diagram do not exist in the drawing, but indicate how my eyes traced round the form while the drawing was being made.

As well as horizontal levels there are vertical and diagonal planes slicing through space that will also contain many related positions. Looking for these spatial connections is just an extension of the comparative looking already described, but now looking and thinking three-dimensionally (**4.8**).

Initially making judgments about the size of things can be unexpectedly confusing. Measuring can help, but it is always best to make a purely visual assessment, and only measure to confirm, not pre-empt, your own judgment. You will then learn to see accurately without needing always to measure. Unless the drawing is "sight size," the scale of the measurement and the drawing are different, so the measurement cannot be transferred directly to the drawing. Two similar lengths should be measured and compared, then this proportion transferred to the drawing, not the original measurement. Measuring is not very accurate on a small scale and is more useful in assessing fairly large relationships at the start of a drawing. The only way the proportions in a drawing can be said to work is if everything finally

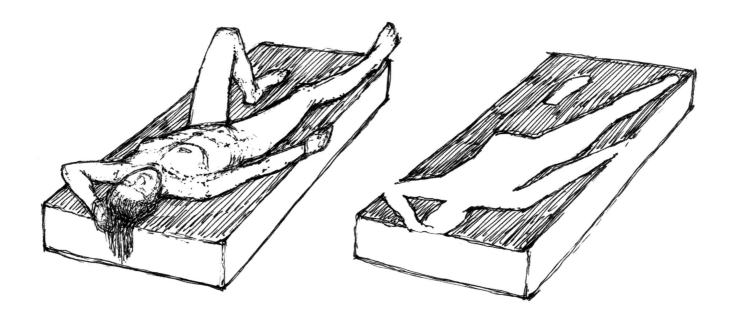

4.9 Negative Shapes and Positive Context

As the model is drawn, parts of the mattress will be left visible. These negative shapes should be considered with as much attention as the figure, because the relationship of the model to the mattress is of fundamental importance. For example, the side of the head is halfway along the top edge and the leg makes a diagonal across the mattress. Always be aware of relationships in all areas of a drawing, not just single parts in isolation.

fits together in a coherent manner, and that is not only achieved by measuring. Henri Matisse (1869–1954) observed, "Exactitude is not truth."

STARTING A DRAWING

At the start of a drawing there is sometimes a temptation to quickly "rough in" a few lines in an attempt to establish the drawing. The trouble is that "roughing in" marks are not based on any real observation or thought, so it is illogical to rely on the least considered marks to be the foundations of the whole drawing. Superficially the starts may look the same, but some considered, broad statements about fundamentals are worth more than any number of vague gestures. First marks should be the result of intense consideration, but this does not mean they have to be neat and detailed. In fact, the reverse is true, because they will probably need amending as the drawing progresses and more reliable observations are made. A limited number of broad, thoughtful marks that will inform the succeeding more detailed observations is how to start a drawing.

Because of the way we see the world, objects are often considered in isolation from their context and are drawn separately, with little reference to their

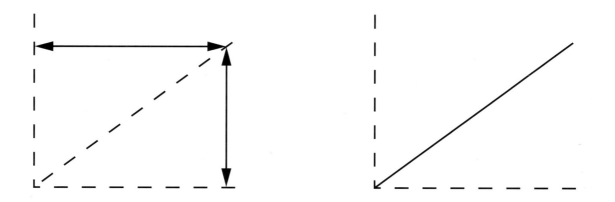

4.10 Assessing Angles

Angles can be difficult to assess, particularly when they are also foreshortened. It is sometimes better to discover the vertical and horizontal relationship of the two ends before drawing the angled line.

surroundings. Inevitably another set of shapes will have been drawn by default on the other side of the lines that describe the object. These new, or negative, shapes contain important visual information and in spite of not having a name like the object, should be scrutinized and drawn with equal attention.

It is vital that all parts of a drawing are considered to be important. In drawing **4.9** opposite it is as necessary to draw the mattress as the figure and the relationship of the figure to the mattress. Imagine the shapes left around the figure. It would be nearly possible to draw the figure by drawing only the mattress.

Angles are difficult to assess. Verticals and horizontals are easier to judge because of their more fundamental quality related to gravity and our sense of balance. It is often simpler to gauge an angle by finding the relationship of the two ends of the angled line first. How much higher or lower is one end compared to the other and how much left or right? Then join the two positions (**4.10**).

Foreshortened angles are even more deceptive because they often do not look "right" to the brain, which is trying to understand what it is, not what it really looks like from an unfamiliar angle. The brain amends what is seen to conform to what we know about an object or situation. Therefore do not believe the

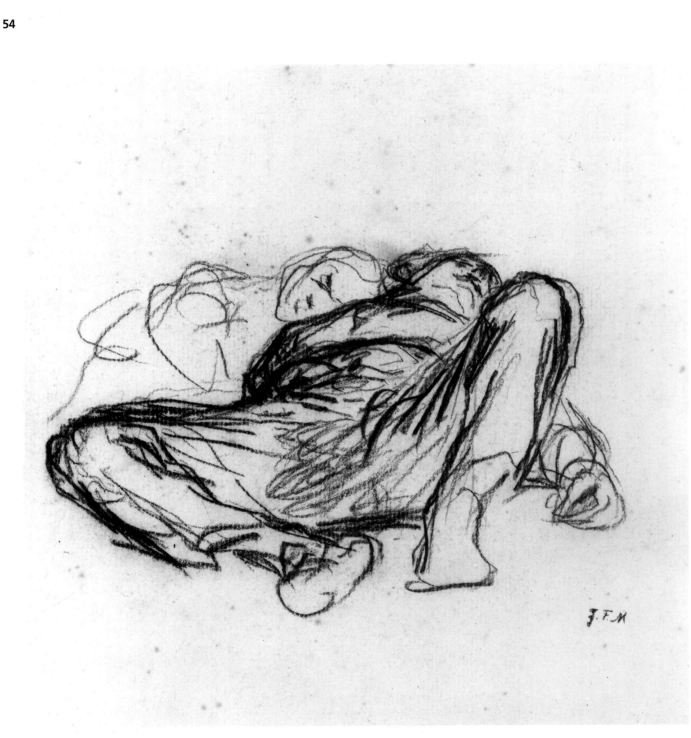

4.11 Jean-François Millet, *Two Sleeping Figures*, study for
La Meridienne, c. 1865. The Ashmolean Museum, Oxford.

Although we know a figure is longer than it is wide, in Millet's
drawing the width of the foreshortened image is far greater
than the height. All the expected proportions have been altered
to produce a convincing representation of a reclining figure.

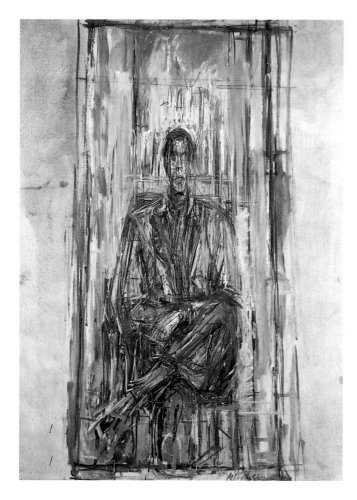

4.12 Alberto Giacometti, *Diego Seated*, 1948. Robert and Lisa Sainsbury Collection, University of East Anglia, Norwich.

Regardless of the materials he was using, Giacometti's working method of slow accumulation hardly changed. So although this is in theory a painting, he only really produced drawings in a range of different media. Giacometti has made no attempt to "tidy up" his marks; the fact that we can see how he arrived at his final statement is one of the "drawing's" main strengths.

brain's preconceptions of how things should look. Make critical observations and discover the real proportions, even if initially they appear to be unbelievable (**4.11**).

Drawings are produced in time and accumulate through a series of observations and the marks made in reaction. Some decisions will be right, others wrong, so be willing to make changes at every stage. Make marks that are positive, but initially not so heavy that they make amendments difficult. When learning to see, drawings need to be treated as experiments, not works of art. It is better to change and amend as observations are refined, rather than be concerned with a "finished" look to a drawing. Neatness has nothing to do with accuracy or quality. It is preferable to have several marks about a position if that is what is needed to get one right. There is no necessity to rub out every change just to make a drawing tidy. In the portrait *Diego Seated* (**4.12**), Alberto Giacometti (1901–66) left the whole history of the work visible, showing how he slowly adjusted and defined his decisions.

After a certain point in making a drawing, a number of reasonably correct relationships will have been established. These should be used as the scaffolding on which the next stages of the drawing are built, therefore indicating what to look for next. This process of allowing the drawing itself to influence the order of its production means that it becomes important to look as critically at the drawing as at what is being drawn. Assessing the drawing will also help in deciding if it is developing according to the original intentions and, if not, what needs emphasizing, what needs to be added or discarded. Learning to see requires a dialogue between the intentions of the person drawing, the object being drawn, and the drawing. All three components need to be "looked at" with equal intensity and imagination.

Ideas to Explore Simple drawings

THIS chapter has been about how we start to draw and has dealt with basic ways of looking needed to make a drawing. It is apparent that thinking in a new visual way is vitally important. Like many rewarding activities, knowledge, experience, and practice are essential preliminaries to success. Drawing is no exception, and just doing lots of drawing is really the best of all follow-up ideas.

So that you get into the habit of automatically asking basic questions about positions, proportions, and relationships, it is sensible to make plenty of relatively simple drawings. This is better than concentrating on a few highly detailed drawings, where most of the time will be spent on issues that are not fundamental to the early stages of learning to draw.

The subject matter of the drawings can be anything you find interesting. However, there is one important consideration: the relationship between objects and their surroundings should always be an equally important part of most drawings.

A simple idea that forces you to be selective and concentrate is to separate looking from drawing. You are only allowed twenty good "looks" at the subject of your drawing. After each "look" you physically move away, perhaps to another room, to make your drawing from memory. This will make each observation seem more intense and special. Your first look should be concerned with simple basic proportions and directions, then progress to more complex information. Make your observations in relationship to a definite idea of what you want the drawing to be about. Remember you cannot draw everything, so select what is really relevant and only draw what you can actually remember from each "look." Do not add marks to make the drawing look "complete"; the important point is the quality of your questions, not, at this stage, the finished look of your drawing.

Proportion and Composition

OUR ability to compare positions, lengths, and areas is a fundamental requirement of a visual language. Drawing the human figure (**5.1**), has for centuries played a part in gaining this ability to assess proportions; without this sense of judging proportions drawing is difficult. However, there is another sense of proportion that is not just about recording the relationship between amounts, but includes making a judgment about the quality of proportion in terms of visual satisfaction.

A single length or amount can never be out of proportion; it can only be out of proportion with another length or amount. The balance between things is therefore the essence of proportion. Unbalanced implies too great a disparity to be satisfying, while balanced, in certain circumstances, can be equally unsatisfactory through a lack of dynamic tension. By implication there must be some ratios that are more "in proportion" and satisfying than others.

We are of course making decisions about proportions all the time in daily life — placing ornaments along a shelf — deciding on the balance of colors in our clothes — the position of a painting in relationship to the shape of a wall. Very often we have an innate feeling that one proportion is better than another, and this perception is shared by others. The idea that there are certain proportions that are intuitively felt and part of a natural scheme of things is not entirely fanciful. Some particularly agreeable proportions have an identifiable mathematical basis and are frequently found in natural forms.

THEORIES OF PROPORTION

Probably one of the most famous proportions is the Golden Section, which is consistently felt to be a most harmonious ratio of lengths. If a group of people are asked individually to put a mark on a line that produces a pleasing division, the majority will intuitively select a point that roughly produces a Golden Section. This golden ratio, first noticed by Euclid in about 300 B.C.E., is 1.618 to 1 or approximately 8 to 5, and its properties have preoccupied philosophers, mathematicians, and artists since it was discovered. The first-century C.E.

5.1 Paul Cézanne, *Male Nude*. The Ashmolean Museum, Oxford.

Learning to judge proportion is one of the reasons why life drawing will always be valuable. This drawing by Cézanne would not look out of place in a life class today, and demonstrates the timeless quality inherent in drawing the human body. Inspiration can be found in the literally thousands of drawings of the human figure, from every period of history.

Golden Section

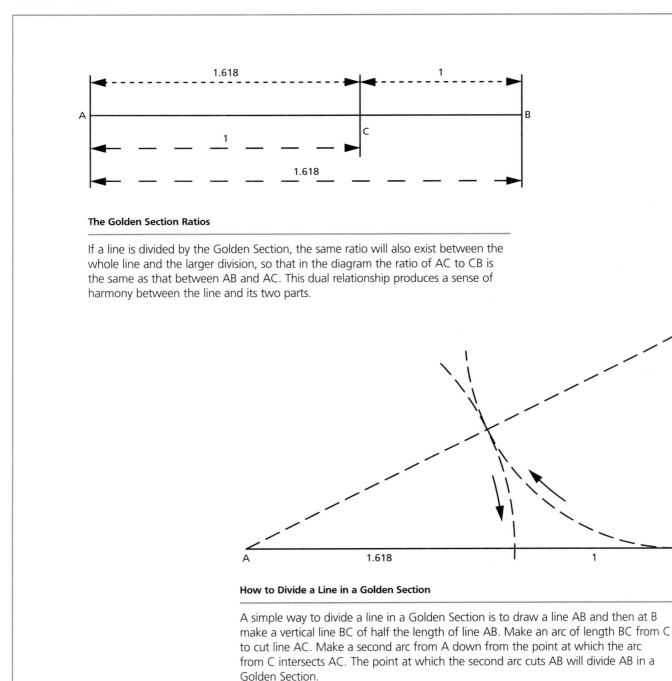

The Golden Section Ratios

If a line is divided by the Golden Section, the same ratio will also exist between the whole line and the larger division, so that in the diagram the ratio of AC to CB is the same as that between AB and AC. This dual relationship produces a sense of harmony between the line and its two parts.

How to Divide a Line in a Golden Section

A simple way to divide a line in a Golden Section is to draw a line AB and then at B make a vertical line BC of half the length of line AB. Make an arc of length BC from C to cut line AC. Make a second arc from A down from the point at which the arc from C intersects AC. The point at which the second arc cuts AB will divide AB in a Golden Section.

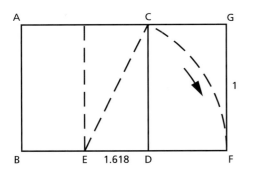

Constructing a Golden Rectangle

Because artists and designers usually work within a rectangular format, dividing areas according to golden proportions is often more relevant. A "Golden Rectangle" is produced by starting with a square, such as that delineated by ABCD in the diagram. Divide the square in half vertically and in one half draw a diagonal EC. Swing EC down in an arc to point F, level with the base of the square. This will then form the baseline of a rectangle ABFG in which the ratio of the long to the short sides is the golden 1.618:1.

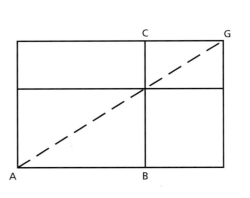

Horizontal Division of the Golden Rectangle

The Golden Rectangle can be subdivided into many further divisions with a golden ratio. To produce a rectangle with two satisfyingly related horizontal areas and a horizontal division that feels natural, draw onto your rectangle a diagonal line (AG). This will intersect the line BC of the enclosed square at a point that produces a golden division of the rectangle.

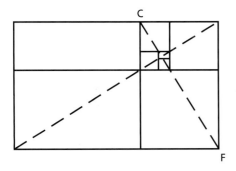

Further Golden Subdivisions

By drawing a second diagonal (CF) onto your Golden Rectangle, the shorter section of the horizontal line is divided into a Golden Section. These subdivisions can then be continued with the diagonals cutting each succeeding line, producing more Golden Rectangles.

5.2 Richard Diebenkorn, *Untitled (Ocean Park)*, 1977. The Museum of Modern Art, New York. Purchase.

Although Diebenkorn was not using theories about proportion in a strictly academic way, this drawing does however show a deep concern for proportion and how shapes relate to and divide a rectangle. A number of Golden Sections are evident, but they were probably arrived at intuitively. The faint traces of earlier marks give fascinating insight into how the design was refined and finally decided.

Roman architect Vitruvius, in his treatise *De Architectura* was aware of the Golden Section. He suggested that the relationship of unequal parts of a whole was at its most satisfying if the smaller was in the same proportion to the larger as the larger is to the whole.

Although the Golden Section and other theories about proportion had a particularly important place in Renaissance art and the Neoclassical period that followed, a number of nineteenth- and twentieth-century artists continued to exploit theories about proportion. Seurat and Piet Mondrian (1872–1944) are obvious examples, and more recently Richard Diebenkorn (1922–93) in America continued to explore ideas about proportion as a fundamental aspect of his work (**5.2** and **5.3**). Le Corbusier (1887–1965) used the Golden Section in his Modulor theory based on the proportions of the human figure (**5.4**). Much of his architecture was designed using this system of related proportions. When he showed Modulor to Albert Einstein, the latter told Le Corbusier that this was "a range of dimensions which make the bad difficult and the good easy."

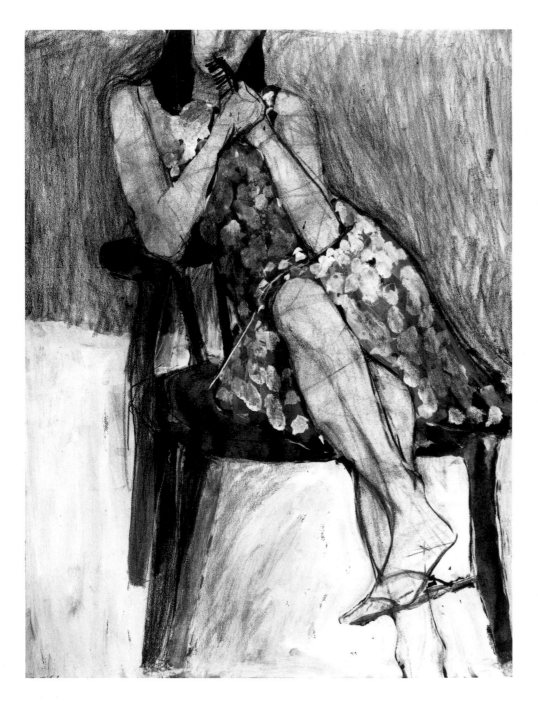

5.3 Richard Diebenkorn, *Seated Woman, Patterned Dress*, 1966. The University of Albany, State University of New York.

Unlike the Ocean Park drawing, this drawing is made from observation, but Diebenkorn is still equally concerned with proportions. By not including all the head or the right foot, he shows that his real interest is in the way the figure relates to and divides the rectangle. The chair seat is on a Golden Section as are the arm-rest, elbows, and knee. The repetitive diagonals made by the parts of the figure divide the rectangle, imparting a structured dynamism to the drawing.

5.4 Le Corbusier, *The Modulor* as in *Le Corbusier, The Modulor: an harmonious measure to the human scale, universally applicable to architecture and mechanics*, London, 1954.

Corbusier's Modulor system of proportion was developed using the Golden Section in relationship to the human figure. He divided a figure with a raised arm in half at the navel and the head to toe distance has the navel on a Golden Section, producing more golden ratios. He used this system of ratios extensively in the design of his buildings.

The importance of the Golden Section and the many other theories of proportion should not be exaggerated beyond their real importance. Obviously, great art and millions of drawings have been produced without reference to any theories of proportion. Today it would be ridiculous to enter a life room armed with preconceived ideas about ideal proportions for the human figure. However, we should not ignore the fact that we do have innate feelings about proportion that inform our judgments and can contribute to our ability to design. The extreme dogmas of the past may be redundant, but having a strong sense of proportion is still invaluable and, most importantly, the comparative way of looking and thinking that is the essence of ideas about proportion is also fundamental to the process of drawing.

Ideas to Explore Applying the Golden Section

MANY of the drawings we make just occupy an undefined area in the middle of a sheet of paper. The only relationships that are considered are between parts of the object or idea being drawn. In some drawings this is entirely adequate, but in many others drawing the context and defining a containing shape should be an important consideration. It allows the surrounding shapes to have a role and a dynamic relationship with the rectangle. In particular, it allows the artist a greater opportunity to design and use a sense of proportion.

To help establish this rather more considered way of working, make a number of drawings of landscapes or interiors. Each drawing should be contained within a definite shape. Assess the subject carefully and place some important accents, divisions, or levels so that they divide the drawing into interesting and visually satisfying areas. Some drawings could use intervals based on Golden Section theories, while others could be purely intuitive. Sometimes the drawings are improved by not only amending the divisions within the rectangle, but also by altering the size and shape of the rectangles themselves. Just be willing to experiment and use your sense of proportion. Do you notice any real difference between the drawings using a theory and the completely intuitive drawings?

6

Light and Tonal Value

WITHOUT light nothing could be seen. The amount of light reflected back into the eye by surfaces produces a range of tonal patterns that allows us to interpret the world. Tone is produced in three ways: tone related to color, tone related to form, and tone produced by light. Human vision does not always make a clear distinction, and the brain can make sense of a situation without fully differentiating between the types of tonal value. However, to make a drawing it is essential to be able to distinguish between the three types and how they are created.

TONAL VALUE/COLOR

Everything has a color, and all colors have a tonal value related to how much light they absorb and therefore reflect. This means that some colors appear inherently lighter or darker than others. For example, a pure yellow is lighter than a pure red or blue.

All parts of the wall in diagram **6.1** receive the same amount of light, but the white wall reflects more light than the colored door and painting; they therefore appear darker. In a monochromatic drawing the color of objects is sometimes implied by giving the darker colors a tonal value similar to the darkness of the real color. This effect is often described as giving "local color" to a black and white drawing.

6.1 Tonal Value – Color

Although the wall, door, and picture receive the same amount of light, they all have a different tonal value. This is because different colors absorb and therefore reflect different amounts of light, making some colors appear darker than others.

Light

6.2 Tonal Value – Form

Form is revealed by light creating different tonal values, depending on the amount of light reflected from each angled surface. Those turned toward the light will be lighter than those angled away from the light.

TONAL VALUE/FORM

In a three-dimensional object more light is received and reflected if a surface is turned toward a source of light; therefore it will appear lighter than similar surfaces turned away from the light. The same tonal value will therefore occur on surfaces at the same angle. By adjusting the tonal value in a drawing, differently angled surfaces can be indicated and the volumes described; diagram **6.2** demonstrates the principle in its simplest form, while Cézanne's drawing of a nude (**6.3**) exploits it in a subtle and refined manner. Carefully observing the way light falls over a surface can be as informative as actually touching the surface. Matisse said, "Drawing lies in making the planes recede and advance in the correct relationship to each other and to the whole, so that you can feel your way over the form."

TONAL VALUE/LIGHT

Tone/light is different from the two previous forms of tonal value. They are directly related to either a particular color or a three-dimensional object, but tone/light is more amorphous, being created by light itself. Light will vary in intensity, cast shadows, fall unevenly, create reflections; it will camouflage as well as reveal (**6.4**). Tone made by light has the potential to create visual drama and atmosphere, but it can also be used to organize a drawing. Areas can be spotlit or lost in shadow, contrasts can be soft and diffuse or sharp and dramatic, and by having a single light source a drawing can be given unity. All this was very well understood by Victor Hugo (1802–85), a leading figure in the French Romantic movement, who, although better known as a poet, novelist, and dramatist, was also an accomplished artist (**6.5**).

A major problem in drawing is that all three types of tonal value can be present together. This can obviously be visually interesting, but it can also result in total visual confusion. It is therefore essential to decide what kind of tonal values are present and how they are to be used if a drawing is not to be completely disorganized. In the drawings by John Constable (1776–1837) (**6.6**) and Seurat (**6.7**) they have used various types of tone, but they have still managed to produce comprehensively organized tonal drawings.

Another important objective is to have one tone scale for the whole drawing and not to describe every minute detail with a complete black to white range of tonal values. This means that, for example, a white object in a shadow will not be white but relatively dark. In relationship to its dark context, it will still take on the appearance of a white object, but in shadow.

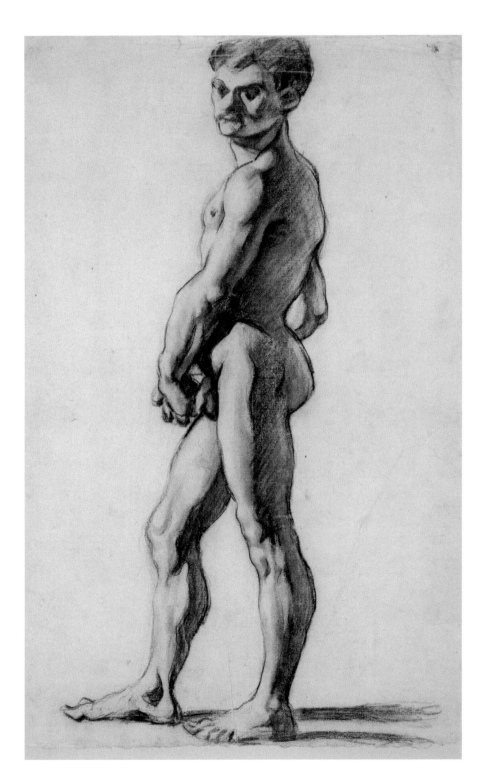

6.3 Paul Cézanne, *Male Nude*, c. 1863.
The Fitzwilliam Museum, Cambridge.

In Cézanne's drawing the light is
coming from the left, illuminating
the front surfaces of the figure.
The transition from front to side –
light to dark — is as carefully
observed as the outline of the figure
and varies in sharpness depending
on the incisiveness of the curve.
A subtle amount of reflected light is
used to describe the back surfaces.

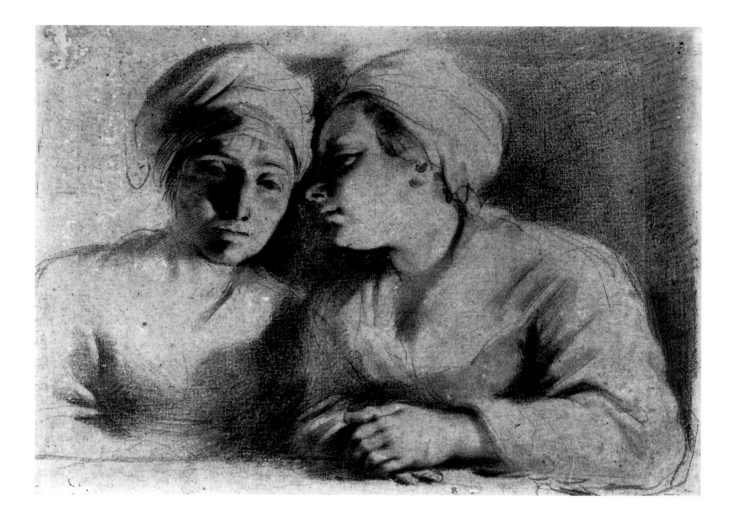

6.4 Giovanni Francesco Barbieri, called Il Guercino, *Two Seated Women*.
The Ashmolean Museum, Oxford.

In this drawing the strong single source of light selectively
reveals or hides the forms. Some areas are totally concealed
in shadows that have a range of soft to very hard transitions,
depending on the type of edge or curve being described.
The rather theatrical lighting also creates a wonderfully furtive
atmosphere for the whispered conversation.

6.5 Victor Hugo, *Castle Above a Lake*.
The British Museum, London.

In this drawing Hugo has used
light and tone deliberately to
illuminate only the dramatically
situated castle, while leaving the
landscape dark. The strong
diagonal design also relies on his
confident use of tonal contrasts.

6.6 John Constable (1805–81),
*View of the Stour with Dedham
Church in the Distance*, c. 1832–36.
The Victoria and Albert Museum,
London.

The boldness of the marks and
the rich tonal contrasts give
this drawing a remarkable
visual energy. In spite of the
very direct brushwork,
Constable has still managed to
delicately describe the church
with a few simple marks.

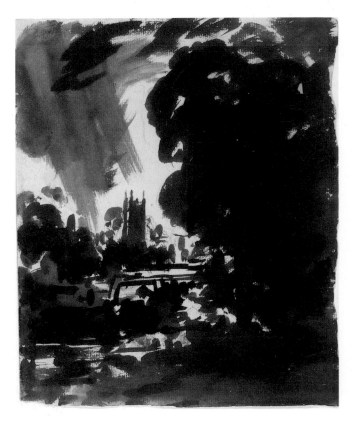

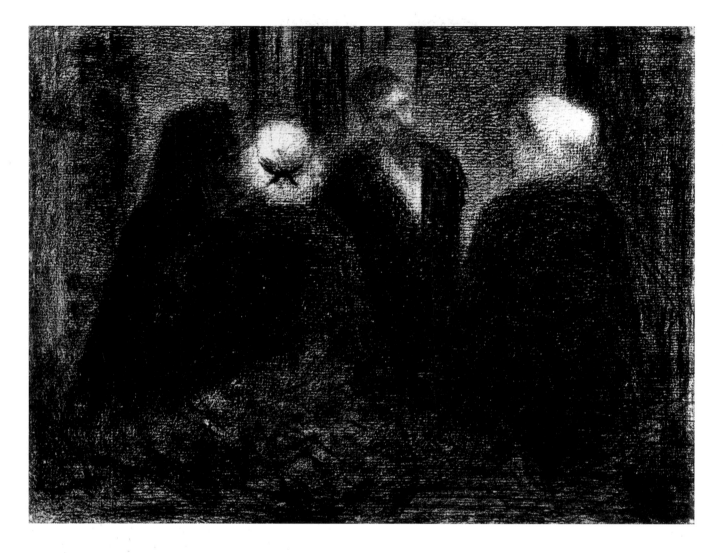

6.7 Georges Seurat, *Family Group. Taste in the High Life*. Private Collection.

Although Seurat has used tone to describe the local color of white hats and dark coats, he has also used tone to indicate the form of the hats and the man's head. The light in a general gloomy luminosity that pervades the whole drawing is the third type of tone used. Seurat has managed to combine all three without losing the structure of the drawing.

Ideas to Explore Using tonal values

THE three different types of tonal value are the key points in this chapter. As we have seen, it can be quite confusing differentiating between them, particularly as they are often all present at once. Because of this it is helpful to make three drawings that deal with each quality separately.

1. *The tonal value of colors*

Choose a subject that is predominately two-dimensional and with no shadows, but contains a wide range of colors. In spite of the subject being full of color, make a drawing that is totally monochromatic by only using shades of gray. This will force you to compare just the tonal values of each hue. Two quite distinct colors of the same tone will appear the same in your drawing. In theory, if all the colors had the same tonal value the drawing would be one solid gray shape.

2. *Tonal value describing form*

On this occasion you will need to select an interesting three-dimensional object that is a single color. It is important that the light is only coming from one direction. Make a drawing that explains the three-dimensional properties of the object by using the tonal variations that occur on the object's differently angled surfaces. Try and keep the tones general and simple without too many exaggerated highlights.

3. *Tonal value related to light*

Arrange a group of objects close together in a still life and light them from the side so there is plenty of tonal contrast, as in the drawing shown here. Light not only reveals objects, but will sometimes also conceal their shape. Now make a drawing, using only three or four different tones, that indicates where the tones alter, not where the edges of the objects occurs. Sometimes the side of one object will be the same tone as the background or the next object, so the edge becomes tonally invisible. When this happens, ignore the shapes of the objects and only draw the shapes of the tonal areas.

7

Three Dimensions into Two Dimensions

7.1 Vincent Van Gogh (1853–90),
La Crau from Montmajour, 1888.
The British Museum, London.

Van Gogh's drawing is an amazing example of how to translate three dimensions into two. He has created this illusion of great distance by exploiting many of the visual clues that the brain has learned so that it can understand form and space. They are the subject of this section of the book.

THE world is three-dimensional, a drawing is flat. The process of translating one into the other is an extraordinary problem, and solving it is often one of the major concerns when making a drawing. Van Gogh's *La Crau from Montmajour* (**7.1**) is a triumphant example of a great artist's skill in addressing the difficulties in depicting an extensive landscape. If as babies we had not learnt about form and space by touching and moving, we would not have any understanding of a three-dimensional world. Memories of these actions informed our eyes and brain, making it possible to reconstruct forms and space in our mind. This model of the world in our brain now allows our eyes to create the sensation of feeling and walking without having to move an inch.

To think and draw three-dimensionally we need to understand its two components — form and space. Although in reality they usually occur together, it is less confusing to discuss them separately.

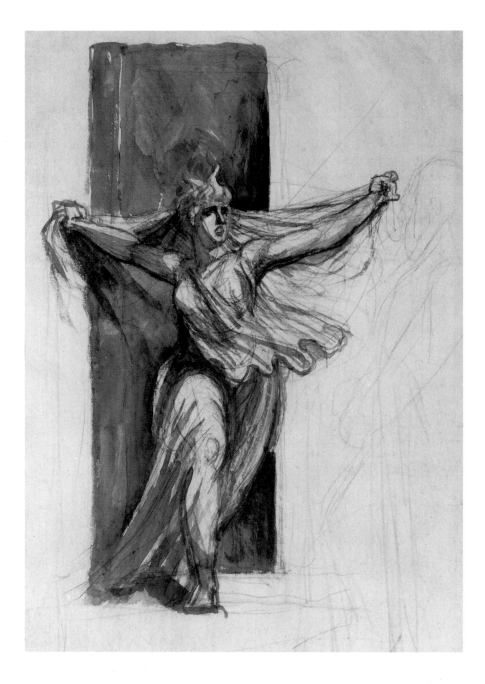

7.2 Henry Fuseli, *Cassandra Raving*. The Ashmolean Museum, Oxford.

This dynamic drawing has the light coming from the top right, strongly revealing the form of the figure. The folds in the drapery, as well as providing dramatic movement and energy, also help describe the underlying volumes.

FORM

Form is revealed by light falling on the surfaces of volumes and being reflected differentially by the varied angles of each plane. Surfaces turned towards the light will appear lighter than those turned away. These tonal variations can be translated into planes that can then be drawn, rather than copying shadows without understanding the forms that create them. Tone reveals the form, it is not the form itself — a point exemplified in Cassandra Raving (**7.2**) by Henry Fuseli (1741–1825).

7.3 Form

These are two drawings of the same piece of rock. The first has only described tonal changes from one small part to the next, with no consideration of the broader tonal structure. The second drawing has subordinated minor undulations to a description of the major volumes by giving the drawing a single overall set of tonal values.

A drawing should have a general tonal structure which is related to the main volumes, not the multitude of minor tonal variations that occur on the major surfaces. If a full tonal range is used to describe even the smallest undulation the drawing will just look bumpy, and the more important and basic volume will become lost in a mass of detail (**7.3 a**). Major tonal areas correspond with the main planes and they will have internal boundaries that are as easily identified as the edge of the object (**7.3 b**).

A

B

7.4 Contour and Form

It is unlikely that the the brick at bottom left would be drawn using the outline above it as a starting point. The series on the right illustrates the far more likely process of describing the individual planes first, allowing the contour to draw itself.

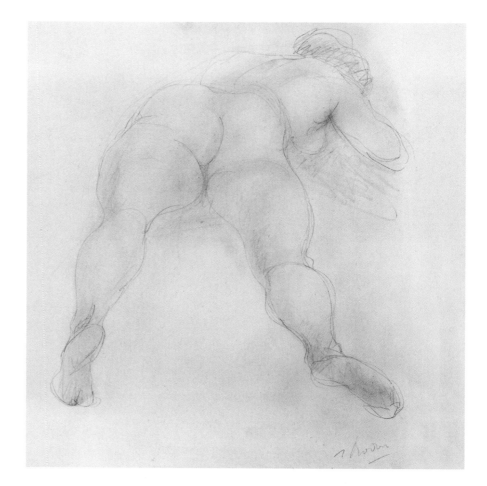

7.5 Anonymous, French, *Reclining figure*. The Whitworth Art Gallery, Manchester.

The contour in this French drawing is not continuous, but overlaps as one volume succeeds the next. The artist has drawn round each form, not along the outline.

Form can also be described without the use of tone as a major component. This requires a line drawing where the contour is discovered by drawing the edges of internal planes that produce the outline. For example, if someone is asked to draw a brick it is unlikely that the outline would be drawn first and the planes after. A more normal way to proceed would be to describe the three visible surfaces and the outline would then have drawn itself (**7.4**).

The same principle will apply to the description of more complicated forms. The contour lines in a drawing must be sensitive to their relationship to internal planes. They should not be a continuous uncritical outline, more appropriate for the depiction of a flat shape. A contour describes the transition from what is visible to what is invisible, and the quality of line needs to vary according to the speed of this transition. Sharply drawn edges imply an abrupt or hard change of angle, while a softer line will suggest a plane turning away more slowly. One volume will often overlap a more distant form, so the order that lines overlap and their weight becomes important. This means that lines follow the form inside the edge, rather than follow the outline in a continuous uninformed line (**7.5**).

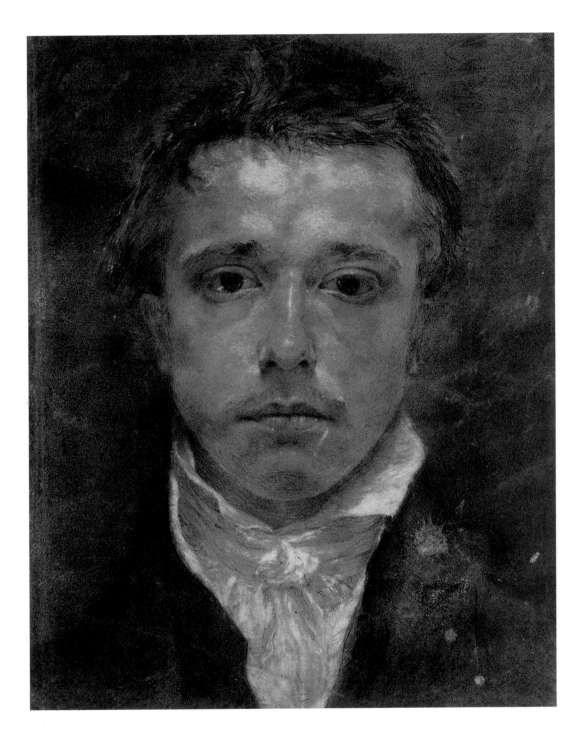

7.6 Samuel Palmer, *Self-portrait*, 1824–25. The Ashmolean Museum, Oxford.

Samuel Palmer, looking with an intense gaze into a mirror, has produced one of the most hypnotic self-portraits ever made. The heightened sense of reality is achieved by a pure single light source revealing the form. The hair, eyelids and collar, for example, are minutely observed and perfectly describe the underlying form of the skull, eyeballs and neck beneath.

7.7 Jean-Auguste-Dominique Ingres, *Sir John Hay and his Sister*, 1816. The British Museum, London.

Although Ingres has used mostly line, with hardly any tonal shading, the volume of the figures is fully suggested. The clothes are elaborately described, but have a dual role of also implying the forms underneath. The braid on Sir John's coat nearly echoes the shape of his ribs, and the pattern on his sister's shawl precisely conforms to the underlying form. Collars, cuffs, folds, and hair all exploit their dual possibilities and assist in creating a real sense of solidity.

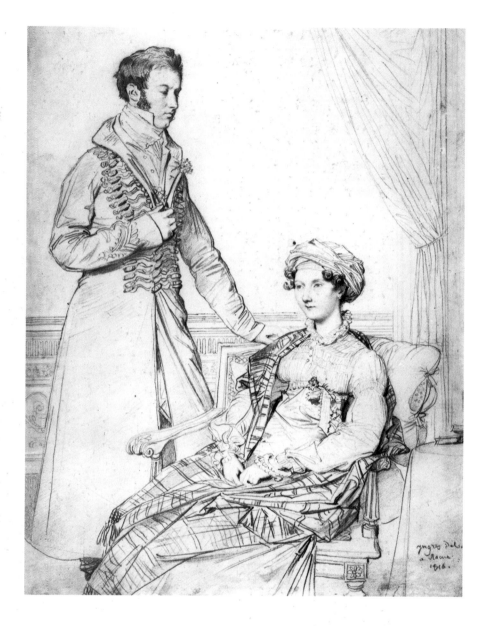

Another important method of describing form is by implication, rather than by overt description. For example, if the features are carefully placed in relationship to one another, the front plane of the head is also described. The same principle applies by carefully drawing the ellipse the eyelids make round an eyeball, a collar round a neck, buttons on a coat, plates on a table, the pattern on a garment, as is demonstrated with masterly effect in a self-portrait by Samuel Palmer (**7.6**). It is important to become aware of the potential to give things a dual role; marks can of course just describe hair, but Ingres and Hans Holbein (1497/8–1543) show how, with more consideration, the hair can be used to indicate the volume of the head under the hair (**7.7** and **7.8**). Sometimes the idea behind a drawing has little to do with

7.8 Hans Holbein, *Sir Thomas Elyot*, 1532–33. The Royal Collection.

The head in Holbein's drawing looks extremely solid, although he has used very little shading to create a sense of volume. The rim of the hat exactly follows the shape of the skull and the hair curves round behind the head underneath the hat. The features are placed precisely on the front plane of the head and the eyelids sit on the curved surface of the eyeball, creating a perfect ellipse.

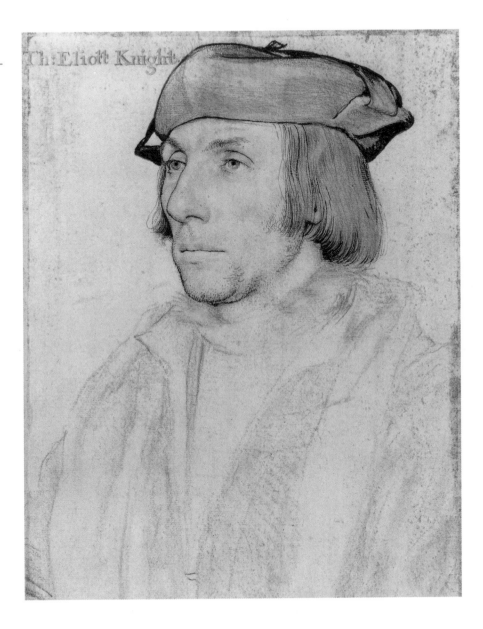

its three-dimensional quality, but being aware of form is an invaluable foundation for one's thoughts, even when it is not the primary motivation for a drawing.

The word "form" has another meaning totally different to its use as a description of volume. It can be used to describe how an idea is given visible structure or the form the drawing takes when organized to conform to a formal idea or intention.

7.9 The Eye and Perspective

Two objects of the same size but at different distances from the eye will have light rays of a different angle entering the eye. This will produce different-sized images when projected onto the retina at the back of the eye and explains why objects appear to reduce in size as they become more distant.

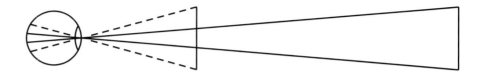

SPACE

Space itself cannot be drawn, only the relationship of objects, surfaces, marks in space can be described. These can then be used to produce a drawing that implies space by their relationships. Perspective, size constancy, texture gradients, position on a ground plane, overlap, and aerial perspective are the visual phenomena that allow us to make sense of space, although the activity of physically moving about in space gave us our initial understanding that it exists.

The way our eyes work is crucial to our understanding of space. Reflected light enters the eye, via a lens, from objects outside and is projected onto nerves in the retina at the back of the eye. Two objects of the same size, but at a different distance from the eye, will produce light rays of a different angle. Therefore an object further away will have a smaller image projected onto the back of the eye and will appear smaller than the nearer object as shown in diagram **7.9**. This is the basis of perspective and several other clues that aid our perception of space. The fact that we have two eyes and therefore see things from two slightly different positions also aids the perception of space, a phenomenon called parallax.

Perspective

Perspective is perhaps the most obvious and all-pervading clue to our awareness of space. Things appear to get smaller as they recede into the distance because of the way our eyes work. This change of scale gives us an accurate measure of distance and is the basis of perspective. The gap between parallel lines gets less and they appear to converge, producing the characteristic appearance of roads and buildings vanishing into the distance.

While drawing from observation it is only too obvious that perspective exists and that convincing and accurate representations of space can be produced without any knowledge of the geometry underlying perspective. There is however geometric perspective, which allows the representation of space to be achieved, not by personal observation as in empirical perspective, but by using

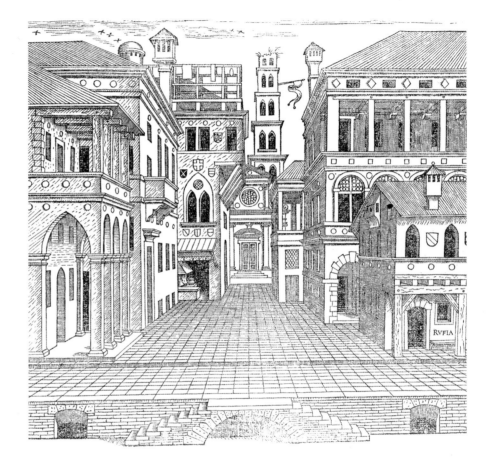

7.10 Sebastiano Serlio, *Stage Set for a Comedy*, taken from the *Architettura*, Paris, 1545.

This woodcut illustration of a stage set gives an obvious demonstration of perspective. All the vanishing lines converge to a single point in the center of the print, producing a convincing illusion of space. The invention of perspective was soon exploited in set design to increase the apparent depth of the stage.

measurements and geometry instead. The theory was established in early Renaissance Italy and assumes a single static viewpoint describing no more than a 30° angle or cone of vision. If more than this is described the theory does not work and strange distortions occur. Geometric perspective is very useful for certain types of drawing such as architects' or designers' visuals or where a very convincing spatial image is desired. Sebastiano Serlio's (1475–c. 1554) treatise *Archittetura* (Paris, 1545) was particularly influential in promoting the use of perspective in stage scenery (**7.10**).

However, for most people an understanding of the underlying principles is all that is needed to produce a satisfactory perspective drawing. Geometric perspective is only loosely connected to the main concerns of this book, which is about looking. Therefore no attempt is made here to cover this aspect of

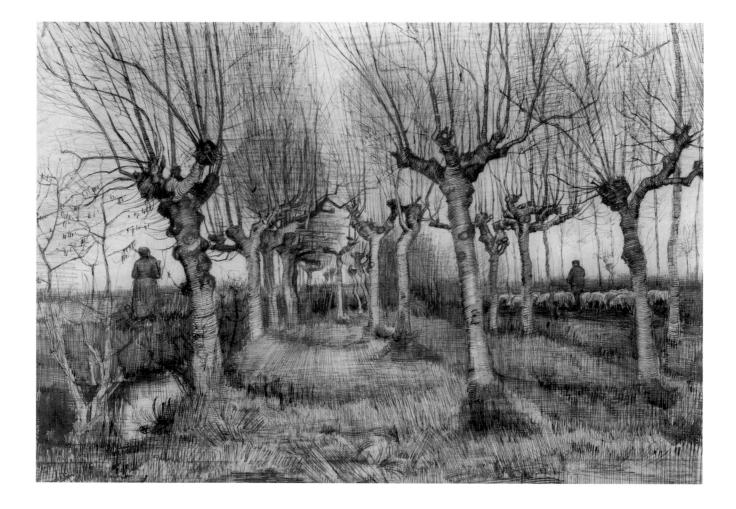

7.11 Vincent Van Gogh, *Pollard Birches and Shepherd*, 1884. The Van Gogh Museum, Amsterdam.

We do not think that the trees in Van Gogh's drawing are getting smaller; we assume they are just getting more distant. The same assumption is made about the size of the figures, sheep, and the gaps between the trees.

perspective in a comprehensive way, but a basic explanation is given in chapter 11 on "Translation and Interpretation."

Size Constancy

Size constancy is related to perspective and the way our brain interprets what we see. Objects appear to get smaller as they become more distant. In fact the apparent size of an object is halved every time the distance away is doubled. We do not think that they actually shrink in size, but assume it is a normal-sized tree or person in the distance (**7.11**). However, to help us understand the world, the brain, in spite of the visual evidence, will adjust what we see by increasing the apparent size of a distant object to nearer its real size. An extreme example of this is how we assume our image in a mirror is the same size as our head. In fact if we measure our reflection it is half the size we

7.12 Texture Gradients and Acuity

As a surface becomes more distant its appearance changes. The shapes will become less distinct and resemble a texture, and finally will appear a relatively featureless surface.

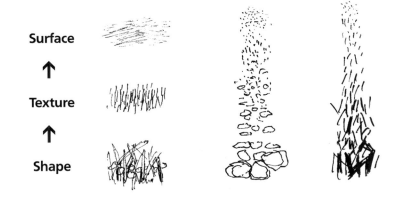

Surface

↑

Texture

↑

Shape

expect. Size constancy has the effect, when we are drawing, of making us underestimate the difference in size between near and far objects. Strangely, the brain does not make this size compensation when looking at the illusion of space in a flat drawing. So by accurately drawing the real scale relationships that we see, space is convincingly described.

Texture Gradients/Acuity

As a surface recedes the size of objects, textures, and marks will get smaller and closer together. This will mean that a coarse texture usually appears nearer than a smooth surface.

7.13 Harold Gilman, *Seascape, Canada.* The Ashmolean Museum, Oxford.

Gilman's drawing of waves lapping on a beach is deceptively simple in the way it creates a sense of distance. The size of the marks, the number of dots, and the horizontal divisions all decrease in a most controlled order as they move towards the horizon.

7.14 Ben Nicholson, *January 4 1953 (Thorpe, Wharfedale in snow).* Pallant House Gallery, Chichester (Hussey Bequest, Chichester District Council, 1985).

Although Nicholson's drawing is made of relatively simple flat shapes there is a strong sense of recession. Our eyes are led through the gap between the two near buildings and up through the picture plane to the fainter distant hills at the top of the drawing.

Although a field is covered equally by grass, its appearance changes as it recedes from the observer. The shapes of blades of grass become textures, and finally the far side of the field appears to be smooth; the same goes for other receding surfaces (**7.12**). By adjusting the marks and acuity in a drawing, space can be implied. Darker, heavier, and larger marks will appear nearer than smaller, fainter marks. Harold Gilman (1876–1919) offers a prime example of an artist exploiting this visual knowledge to achieve an effect in his drawing *Seascape, Canada* (**7.13**).

Position on the Picture Plane

Objects drawn on the area of the picture plane that might be considered to be representing the ground will appear to be more distant the higher they are placed, an effect seen in a drawing by Ben Nicholson (1894–1982), in which nearby buildings frame a view of hills (**7.14**).

7.15 Henri Matisse, *Le Coupe de Raisin*, 1915. Private Collection.

Matisse has used the overlapping grapes on the right-hand side to describe the depth of the dish. He has also used varying thicknesses of line to enhance the feeling of space. The nearest grape has been drawn with a relatively dark line, but as the grapes recede the lines become fainter.

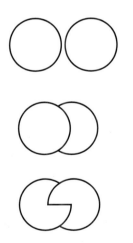

7.16 Overlap

In the first diagram the two disks appear to be equidistant from the viewer. In the second pairing, although the disks are of equal size, there is no doubt that the one on the left appears closer. The final diagram shows a slightly more complex spatial relationship, purely implied by the order of overlapping lines.

Overlap

The order in which shapes overlap each other indicates position in space. Therefore the order in which lines and shapes are drawn needs to be carefully considered so that the way they overlap will strongly indicate their spatial position. This principle is demonstrated by Henri Matisse in his drawing of a bowl of grapes (**7.15**) and further elucidated in the diagram to the left (**7.16**). Overlap is also an important ingredient when describing foreshortening in an object.

7.17 Claude Lorrain, *The Tiber above Rome.* The British Museum, London.

Although other qualities contribute to the spatial effect in Claude's drawing, a major factor is the way he has controlled the tones to describe the effect of aerial perspective. The near trees and their reflections in the water are dark with plenty of contrast, but by the time he is describing the distant hills the tones and contrasts have been greatly reduced.

Aerial Perspective

Water vapor in the atmosphere modifies the appearance of objects as their distance from the observer increases. Distant objects are viewed through more air, so there is greater opportunity for water vapor to scatter the light and change their appearance. The effect is that distant tones will contain less contrast — dark tones will get lighter and light tones will get darker as in the view of the Tiber by Claude Lorrain (1600–82) (**7.17**). Colors become desaturated — more gray — and bluer because the red light is scattered more than the blue. The sky is blue so we associate blue with distance and by contrast warm colors are generally felt to appear nearer. In a drawing, modifying tones and colors to conform to these principles will create a sense of space.

Ideas to Explore Describing three dimensions

DESCRIBING the three-dimensional world on a two-dimensional surface is one of the most sophisticated problems in drawing. This chapter has described the visual clues that allow us to achieve this transformation. We are surrounded by forms and space, so it is not a problem finding a suitable situation to draw. Make notes about which spatial cues you exploited and which proved the most successful.

Here are two proposals for drawings to add to your own ideas.

(1) Choose an object that has markings or features on its surface. This could be a label on a can or bottle, patterned material draped over an object or figure, the features and hair on a head. Make a drawing that describes the three-dimensional quality of the object by only using the surface markings and how they relate to the underlying form.

(2) Place a number of objects on a horizontal surface that is at eye level so that you can only see the objects, not what they are resting on. The objects should be at different distances from you and some should overlap. Now make two drawings that ignore the actual appearance of the objects, but imposes a formal structure that explains their position in space. The first drawing, as illustrated below, uses only lines and they start thick and become thinner as the objects become more distant. In the second drawing the same principle applies, but no lines are used, just tonal areas as with the illustration on page 72.

The important thing to remember is that the actual tones and appearance are not described, but a visual formula is imposed to indicate where the objects are in space. Although this is a fairly extreme form of selection it is important always to limit the reasons for making a drawing. You cannot draw everything in each drawing. Translation, not imitation, is the essence of drawing. Space has been described by just varying line thickness or adjusting tonal values.

Mark-Making

8.1 Rembrandt van Rijn, *Jael Killing Sisera.* The Ashmolean Museum, Oxford.

The individual marks in the drawing bear little resemblance to the event described. However, by some mysterious alchemy, Rembrandt has transformed his energetic marks into a vivid equivalent of the drama taking place. As the drawing progressed the marks became more vigorous until Rembrandt's final gestures were as violent as the murder.

MARKS in a drawing can be anything — a dot, a line, a smudge, a solid area. They can be isolated or grouped together to form larger units. They are the building blocks of drawing and the physical evidence of the artist's thoughts and resulting hand movements. The most extraordinary thing about marks is that individually they often bear little resemblance to what is being described in the drawing. The world is not made of dots and lines, but the visual ambiguity of marks allows the observer to transform them into equivalents of reality, whether a tranquil landscape or a violent scene (**8.1**). The most extreme example is the line. There are hardly any lines in nature, only the edges of shapes and objects abutting one another, and yet we immediately understand a line drawing. This is mainly because our brain is adept at recognizing objects by searching for their edges, and lines in a drawing are often the equivalent of an edge. Marks need to be "read" and translated to produce meaning. Constable

8.2 Jackson Pollock, *Untitled,* 1943.
The Pierpont Morgan Library, New York.

This virtuoso drawing demonstrates an amazing range of marks using ink, wash, and watercolor. It is also a strange mixture of description and intuitive mark-making.

understood this when he said, "We are reminded, not deceived" by a drawing.

An ability to make marks that accurately represent the artist's intentions in all their various forms is obviously important. This skill develops in response to the increasing ability to see the world, which in turn will demand a larger and more subtle visual vocabulary. The process of becoming more versatile needs to be both adventurous and disciplined, fostering both subtle dexterity and intellectual sensitivity. At the same time, as Jackson Pollock (1912–56) exemplifies, it is important not to exclude intuitive or dynamic reactions when they are the obvious response to feelings and emotions (**8.2**).

8.3 Marks

Pencils, pens, crayons, and brushes have been used to make this page of marks; some are careful and considered, others gestural, even accidental. Ideas and imagination are more important than technical virtuosity alone, but without a reasonable degree of technical fluency it is often difficult to produce images that do the ideas justice.

The way marks are used will vary enormously from being very conspicuous and virtually the subject of the drawing to being quite anonymous and completely subordinate to what is being described. A surprisingly limited number of different qualities of line, for example, are used in early attempts to draw. With more experience and dexterity, lines can have a great range of meaning and expression: thick or thin, light or heavy, sensitive or course, soft or sharp, straight or rhythmic, directional or meandering, fast or slow, tentative or confident, exploratory or decisive, variable or consistent. Marks operate singly or grouped to form areas of tone or shadow by hatching or accumulating. Certain types of mark are closely related to texture, even simulating the sensation of touch. Unexpected marks are the by-product of arbitrary and chance actions such as blots, dribbles, stains, rubbings, or accidents.

While it is important to experiment and become articulate and confident with mark-making, the impression must not be engendered that every drawing has to be an outlandish visual cacophony. In fact the reverse is true; a few sensitively understood methods of making marks will be discovered which will form each artist's personal repertoire. Having found a vocabulary that facilitates the expression of their ideas, artists become recognized by them. Rembrandt (1606–69), Van Gogh, and Paul Klee (1879–1940), for example, are all easily identified by the particularly characteristic marks that they used.

Diagram **8.3** is a sample of marks which could be a catalyst for some personal experiments.

Ideas to Explore Marks and creating surface textures

SOMETIMES it can be surprisingly hard to invent lots of different marks out of your head. Carefully studying a section of natural or man-made surface can be particularly stimulating and generate many unexpected ideas about marks and textures.

Cut a 4 in/10 cm square hole in a piece of card or thick paper. Look for an interesting surface and place the frame over a small part of the surface so that an area is isolated and made more particular. Earth, tarmac, wood, grass, materials that are woven, torn or stitched, crumpled foil or paper, peeling paint, skin, nuts and seeds, or a cane chair seat are some of the the types of surfaces that could be selected. A boundary between two different surfaces is a possible further option. Produce a series of intensely observed drawings the same size as the square hole, using appropriate drawing materials. Some surfaces might also be recorded by rubbing a piece of paper that is placed over them with a soft pencil or crayon (frottage). When a number of drawings have been made, the idea can be extended by making additional drawings that enlarge either the whole or part of the original work. Radically changing the scale of a surface or texture will often result in quite unexpected images and qualities, particularly if a different medium is used. It is important that the marks in the original drawings are accurately enlarged by more carefully observed drawings. If the work degenerates into generalized pattern-making, then nothing new is learnt.

Nuts and seeds

Cane chair seat

Transitions and Visual Relationships

9.1 Samuel Palmer, *Early Morning*, 1825. The Ashmolean Museum, Oxford.

This amazingly rich and atmospheric drawing is filled with contrasting shapes and textures that could have produced total confusion. In fact the design is quite clear, having been organized into a few tonal groupings. The different textures are also kept to distinct areas and not scattered like confetti. The end result is sublime romantic profusion.

A DRAWING will contain a number of related positions and shapes which will produce boundaries between the different parts of the drawing. How these boundaries are defined and how the transitions from one area to the next are achieved is an important consideration at every stage of a drawing. A boundary is visible when some kind of change or contrast exists, for example when one area is lighter or darker than the next, a line divides two areas, the color changes or is modified, the number of marks increases or decreases, or a different material or medium is used. Samuel Palmer (1805–81) controls a high number of such boundaries in his *Early Morning* (**9.1**).

If an actor spoke with the same level of sound, tempo, and expression his performance would lack vitality and structure, and the meaning of the play would be less clear. It is the same in a drawing; contrasts, punctuations, and transitions are also an essential ingredient of a visual language if it is to have

9.2 Pablo Picasso, *Minotaur and Dead Mare in Front of a Cave*, 1936.
Musée Picasso, Paris.

Picasso has kept 90 percent of the tones relatively dark, with only the white horse, giving it extreme dramatic focus. He has also concentrated the strongest tonal contrasts and energetic movements in the vicinity of the horse, adding to the drama. The minotaur, the veiled head, and the hands at the cave entrance, are by contrast very close in tone to their surroundings. This produces a subdued context, in opposition to the central struggle. It is a masterful example of how to organize a complex drawing into a simple, but dramatic visual statement.

any diversity or subtlety. They are important tools in the organization of a drawing. By being either diffuse or obvious, certain parts of a drawing can be emphasized to give pictorial structure, space, dramatic focus, and meaning. An example of the use of such emphasis is *Minotaur and Dead Mare in Front of Cave* by Pablo Picasso (1881–1973) (**9.2**).

Transitions

The ability to create and use an extensive range of transitions is closely connected to the previous chapter, because transitions are obviously made with marks. The process of acquiring a vocabulary of marks can easily be extended to thinking about their use in providing change from one area to another. How one part of a drawing connects or contrasts with other areas is an important consideration when developing a drawing. Transitions can range from soft and extended to hard and abrupt, thus helping to organize a drawing and giving it visual vitality and subtlety.

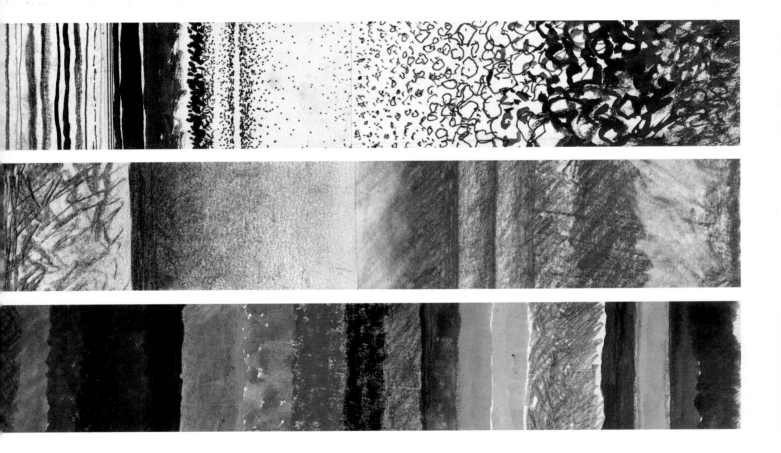

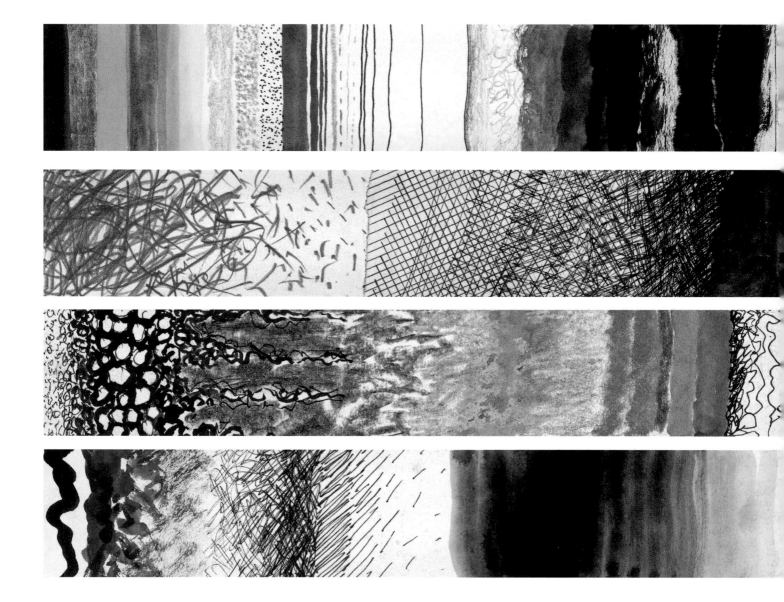

Contrasts

It is easy during a drawing to forget all the alternatives that are available to create transitions, so try to become fluent in remembering possible options. Here are some of the contrasts that could be used.

Soft/hard	Symmetrical/random
Sharp/diffused	Geometric/organic
Light/dark	Near/far
Small/large	Under/over
Thick/thin	Warm/cool
Rough/smooth	Pure/desaturated
Transparent/opaque/translucent	Complementary/analogous
Separate/overlapping/touching	Subtle/coarse
Flat/three-dimensional	Detailed/broad
Few/many	Expanding/contracting
Regular/irregular	Positive/negative
Shiny/matt	Tentative/bold
Plain/decorated	Simple/complex

Ideas to Explore Working with transitions and contrasts

IF drawings are to have any real subtlety, how one area relates to the next is of vital importance. The list of contrasts above provides starting points for a whole series of drawings concerned with moving visually from one area to another, as with the seven bands on pages 98 and 99, and in the example below. Some contrasts need to be abrupt or obvious, but it is equally important to attempt to make others only just visible. This will allow different qualities to flow or group together to make larger units that still remain visually interesting, but now also contribute to the design of the drawing. Use a wide range of materials to fully exploit the ideas in this chapter.

10

Materials and Techniques

MATERIALS have two basic roles: things to draw on and things to draw with. By far the most common surface to draw on is paper, but any reasonably smooth surface can be used, as ancient cave artists demonstrated. There is an enormous range of paper available, both manufactured and handmade. Reasonably substantial drawing paper is relatively inexpensive and is produced in a range of thicknesses and sizes, from individual sheets to large rolls. It is versatile and can be used with materials such as pencils, crayons, pens, etc. Basic drawing papers will take water-based materials, but they are not always the ideal surface, often being too smooth and insubstantial. Heavier watercolor paper especially made for

10.1 Georges Seurat, *Le Laboureur*.
Musée du Louvre, Paris.

Seurat used a slightly textured paper for most of his drawings. If he did not press too hard with his black conté crayon only the top surface of the rough paper was darkened. This meant that white paper remained in the hollows, producing Seurat's characteristic luminous shadows. Even the paper-maker's name has been revealed (to the right of the figure) by this technique.

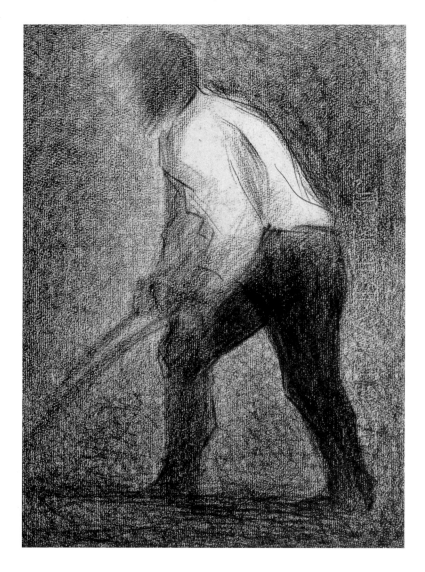

use with liquids is worth the extra expense. Drawing on paper with a slightly rougher surface is worth experimenting with, particularly if chalks, soft pencils, or charcoal are used. Seurat's drawings would have looked totally different if he had used smooth paper (**10.1**).

Paper-making is not very difficult, and amazing qualities can be achieved, not only to do with surface texture, but by introducing colors into the pulp before it dries.

Drawing paper is usually sold in rectangular sheets, so the starting point for most drawings will be on a rectangle, regardless of what is being drawn. It is only too easy to let this proportion dictate the design of the drawing, rather than deciding if it should be long or square, vertical or horizontal; only occasionally will the sheet of paper's proportion's be right.

Paper needs support, so a drawing board is essential equipment. For general use a board slightly larger than the standard sheet of paper will be the most useful, allowing the use of a reasonably large sheet, but not being too cumbersome. A means of attaching the paper to the board is needed; this can be pins or clips, depending on whether the board is wood or a hard laminate.

Things to draw with can be wet or dry, but their use is not discrete and they are often used together in the same drawing. Since its invention by Nicolas Conté in the late eighteenth century, the graphite pencil has become the most habitually used drawing instrument. It comes in varying degrees of hardness, depending on the amount of clay that is mixed with the graphite, and is graded 6H (the hardest) to 6B (very soft), with HB in the middle. The pencil's popularity is understandable; it is wonderfully flexible and capable of producing an enormously varied and expressive range of marks, as shown by Ingres, one of the first artists to exploit its potential (**10.2**). The pencil format has been extended to contain a range of materials other than graphite, including colored crayons and chalks. The main characteristic of all pencils is that they can be sharpened to a point and therefore are good at making precise dots and lines, rather than producing areas of tone.

Sticks of chalk, charcoal, conté, and pastel generally produce less precise marks, but are valuable when larger tonal areas need to be drawn, although they obviously can make linear marks. They also tend to require a broader approach, so a larger scale of drawing is usually more appropriate. In general these materials are rather powdery and smear badly, so when a drawing is completed it should be fixed. Fixative is sprayed over the finished drawing using a diffuser or an aerosol, making even a charcoal drawing reasonably permanent.

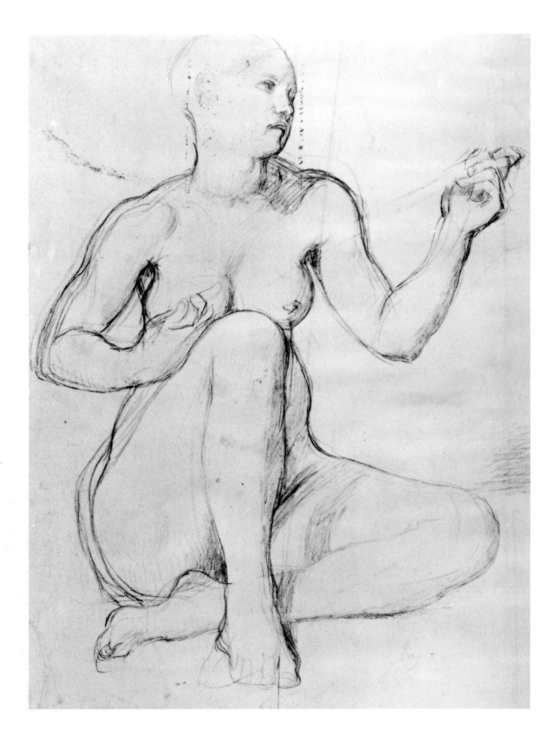

10.2 Jean-Auguste-Dominique Ingres, *Seated Nude*. Private Collection.

The modern pencil is probably the most versatile of drawing
instruments. This drawing shows the diverse and subtle range of marks
that are possible with it and how easily amendments can be made.

10.3 Willem De Kooning, *Untitled*
1950. Gift of Katharine Kuh, The Art
Institute of Chicago.

De Kooning has dribbled paint to
produce speeding and spiraling
lines and then scraped them with
a palette knife to make
contrasting tonal masses. These
early experimental black and
white drawings led to his later
full-color paintings.

An eraser, as well as being used for removing unwanted marks, should also be considered as a useful drawing implement. Drawings made with charcoal or soft graphite frequently require light areas to be re-established by drawing with an eraser.

Another large group of drawing implements are self-contained pens. They are as convenient to use as a pencil and come with a range of tips made from balls, fibre, and fine metal tubes. Their main weakness is that it is difficult to vary the thickness and quality of line or produce any tonal gradation. This means that they can make rather anonymous lines that inhibit subtle expression. A pen with a nib produces a greater range and quality of mark because the nib responds to pressure, allowing the thickness of the line to vary. Although there is the disadvantage of needing a pot of ink, the additional advantage is that the ink can be diluted and grayed so that it integrates with washes of tone.

Liquid drawing materials offer the possibility of large tonal washes, as used by Willem de Kooning (1904–97) (**10.3**) with soft gradations, as well as lines

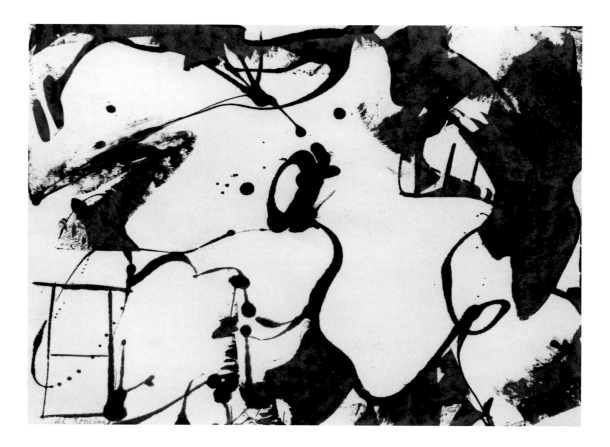

10.4 Richard Diebenkorn, *Seated Woman, Patterned Robe*. 1963. The Baltimore Museum of Art: Thomas E. Benesch Memorial Collection, BMA 1970.21.3.

This work started as a linear conté crayon drawing, but was completed by identifying large tonal masses with solid areas of diluted ink. This totally altered the drawing by leaving new light negative shapes that have become major components in the design.

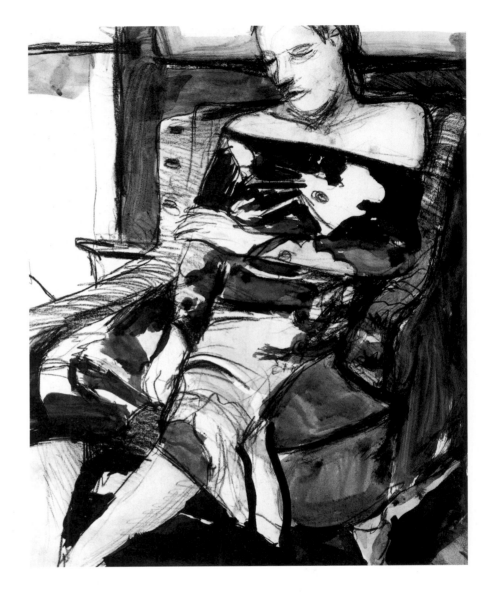

and marks produced by pens and pointed brushes. Many inks are waterproof, so non-waterproof inks should be used if they are to be diluted for a particular effect (**10.4**) or amendments made on the paper. Water-based paints are either translucent watercolors or gouache, which is opaque. They can be used together, but gouache paint will tend to obliterate preceding layers of a drawing, while watercolors will allow previous work to show through.

As well as all the conventional artists' materials, it is valuable to discover other less predictable methods. Sticks, sponges, sprays, fingers, rollers, stencils, and collage can be used in a drawing. Dyes, bleach, varnish, wax, coffee, fabric, and found objects or scratching, gluing, stitching, cutting, tearing, and folding can all extend the scope of a drawing (**10.5**).

10.5 Pablo Picasso, *Minotaur*, 1933. Museum of Modern Art, New York

Typically Picasso has felt totally free to exploit any material at hand in this design for a magazine cover. On the wooden base he has attached a collection of found papers, cloth, and even a leaf, before finally placing a pencil drawing of a minotaur in the center of the design.

Having a wide collection of materials readily available, so that choices are possible, is obviously a good idea. A portable toolbox that will hold this wealth of material makes sense. This box will also provide a home for more mundane but essential items such as a knife, sharpener, ruler, and water pot.

Techniques and materials need to be enjoyed and exploited, but it is important not to become exclusively reliant on skills at the expense of ideas and imagination. Most techniques are not that complicated and develop naturally alongside the increasing visual demands of learning to draw. The only way to discover the materials and methods that fit one's own individual needs is to draw and use them.

Ideas to Explore Paper and other drawing materials

ALL aspects of learning to draw rely on practical experience, but materials and techniques in particular need the physical process of actual use to become fully understood. Several of the topics in previous chapters have involved the extensive use of materials to achieve different qualities of mark. This means that the use of pens, pencils, and brushes will be reasonably familiar. However, two areas have received less attention and should not be overlooked.

The surfaces we draw on can easily become routine and hardly considered. A good drawing paper will be adequate for most activities, but it is sensible to be aware of alternative types of paper and how they can affect the look of a drawing. Obtain several different types of paper, in particular some with a different and perhaps rougher surface than you normally use. If you use inks or watercolors, some thicker watercolor paper would be useful to experience. It will not distort as much as ordinary drawing paper when liquid is applied and allows scratched amendments to be made to marks created with permanent inks or colors. Thicker and tougher papers are also a better foundation for a collage if a wide range of materials are to be attached.

Using paper that is not white allows the use of light as well as dark in a drawing. Fairly neutral colors are preferable; brightly colored paper is usually a distracting novelty and adds nothing to the quality of the drawing. If you can find the specialist equipment and advice, take the opportunity to make paper, particularly if you find surfaces and textures interesting.

As well as trying different papers, the use of less conventional materials can stimulate new ideas. Make some drawings using the unfamiliar drawing implements and materials suggested in this chapter. They are not going to be appropriate, in most instances, for making very naturalistic drawings, so be selective in what and how you choose to draw. You may only use some of these techniques once, but others will help broaden your visual vocabulary. Getting into the habit of experimenting and being open to new ideas is part of being an artist.

Translation and Interpretation

11.1 Canaletto, *Architectural Capriccio*, Victoria and Albert Museum, London.

Canaletto has attempted to produce a complete illusion of space by using perspective. He has positioned the vanishing point in the arched doorway, so that the eye is carried right into the building, encouraged by the vanishing paving slabs in the foreground. The house on the right defines and encloses the near space, which then opens out to a distant view on the left.

ART is not nature. Drawings are made by imaginatively translating a thing, situation, or idea into its graphic equivalent. For example a two-dimensional representation of a real three-dimensional situation is obviously not the same, but a complex translation into a new form. To help achieve this translation a number of formulas and conventions have been invented, some very formal like geometric perspective, some very pragmatic like Cubism. A drawing's appearance is dependent on the method adopted and can vary from one attempting to create an illusion of reality at one extreme (**11.1**), to one that accepts the flat surface of the paper and translates the three-dimensional world into a new two-dimensional form or structure (**11.2**). The drawings by Canaletto (1697–1768) and Lyonel Feininger (1871–1956) demonstrate these two extremes: although in the Feininger there is some overlapping depth, he is not attempting to produce an illusion of space like Canaletto.

PERSPECTIVE THEORY

The attempt to produce an illusion assumes a single static viewpoint, with the eye operating a bit like a camera lens, providing information for the brain to use perspective as a formal basis for the structure of the drawing.

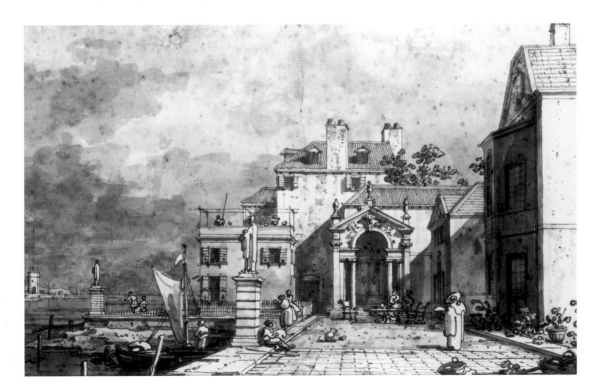

11.2 Lyonel Feininger, *Vollersroda*, 1918. Los Angeles County Museum of Art, Graphics Arts Council Fund.

Unlike Canaletto, Feininger was not interested in describing vast distances. He disregarded perspective and accepted the two-dimensional surface of the paper as an important element in his drawing. The buildings dematerialize into a series of facets and interpenetrating planes that have depth, but little space. Although this drawing was strongly influenced by Cubist ideas, it also retains some of Feininger's interest in light and movement.

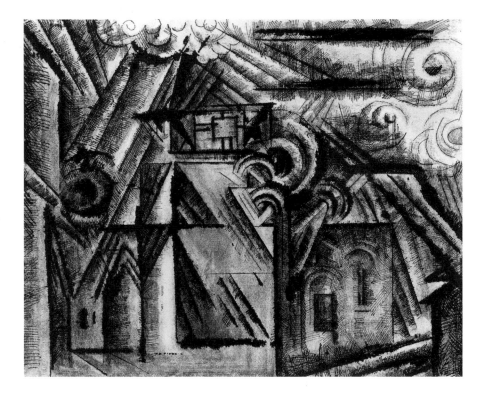

Although this is the most common and in some ways the most natural way to record what we see, it is not the way we understand our surroundings. We accumulate many separate bits of information from more than one position which the brain combines, using past experience and knowledge, into a more complete understanding of what we are looking at. A drawing like **11.3** is visually coherent and informative while employing many different points of perspective. In comparison Steinberg's *View of the World from 9th Avenue* (**11.4**) combines an amazing collection of images that graphically reflect how an individual imagines his environment.

The synthesis of ideas and information into a drawing is often assisted by the use of one of the geometric projection systems. Although many of these systems have their basis in technical drawing and can be used very formally, most artists have exploited them in a far less rigid manner. The most widely used method of describing space on a two-dimensional surface, at least since the Renaissance, is perspective, mainly because it mimics how the world looks. We are all aware that things reduce in size and lines converge as they recede, but we do not necessarily understand the underlying principles of perspective.

11.3 Edward Bawden, *Menelik's Palace: The Old Gebbi.* The Imperial War Museum, London.

Bawden could not have seen everything in his drawing without considerable head movement. He has therefore combined several different views into a single image, which does not look strange or unconvincing. It also relates to the normal way we see by scanning and amalgamating information.

114

11.4 Saul Steinberg (1914–99), *View of the World from 9th Avenue*, 1975. Crayon and graphite on paper, 20 x 15 ins (50.8 x 38.1 cm). © 2005 The Saul Steinberg Foundation/ARS, NY and DACS, London.

Steinberg obviously could not have seen all he included in his drawing. It nonetheless gives a very clear image of how often we selectively think about and imagine the world.

Obviously lines cannot converge for ever and eventually everything meets at the horizon. The horizon line in perspective is the horizontal level opposite the observer's eyes when looking straight ahead, hence the term "eye level." This level is fundamental to perspective because all angled horizontal lines, regardless of their height above or below the horizon line, will eventually vanish at this level. However, all lines at eye level, whatever their angle to the horizon, will remain horizontal on this line.

On the horizon line there will be particular points, called vanishing points, to which parallel lines will vanish. The most important one is the central vanishing point; this is the position on the horizon directly opposite the observer's eye. It is the point at which all lines at right angles to the horizon appear to vanish. When drawing it is most useful to be aware of the eye level as this will help to assess the angles of vanishing lines. Horizontal lines above the eye will vanish down, those below will vanish up towards the horizon.

In a simple diagrammatic form, a rectangular volume, such as a room or building, would be drawn in perspective as in diagram **11.5**. If the walls are parallel or at right angles to a person, then there would be a single vanishing point. The walls at right angles to the viewer would appear to vanish and the parallel walls would reduce in size as they became more distant. If a building is at an angle the walls would now vanish to two vanishing points on the horizon (**11.6**). If the imagined viewpoint was higher, the eye level would also be higher, resulting in a changed aspect to the drawing (**11.7**).

The unique basis of perspective is that, unlike other projection systems, it totally depends on the relationship of the observer's position to the object being drawn. If the observer moves, the drawing changes. As well as making it possible to accurately measure back in space, perspective theory is extremely comprehensive, covering for example the rendering of inclined planes, things vanishing vertically as well as horizontally and shadows,

11.5 Single Vanishing Point

If the walls of a room are at right angles to the horizon line, they will vanish to a single vanishing point.

11.6 Two Vanishing Points

If a building is at an angle to the horizon line, the walls will vanish to two vanishing points

11.7 Two Vanishing Points, with a High Eye Level

If a building is viewed from a higher position, the horizon line will also be higher – increasing the angle of the vanishing lines.

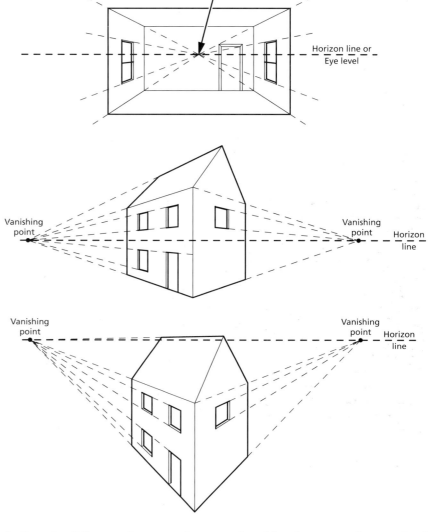

including the difference between those produced by the sun and an artificial light source. It takes a whole book to cover all aspects of geometric perspective theory, so all that has been attempted here is to give sufficient information to understand the basic idea.

OTHER GEOMETRIC SYSTEMS

In addition to perspective, there are many other drawing systems such as horizontal, vertical, oblique, isometric, axonometric, etc. They can all be used equally successfully to give a drawing its structure and form. They help solve the problem of describing volumes on a flat surface and are less reliant on

11.8 Alternative Drawing Systems

The three objects have been drawn using five different systems. This has produced remarkably disparate, but still easily recognizable images.

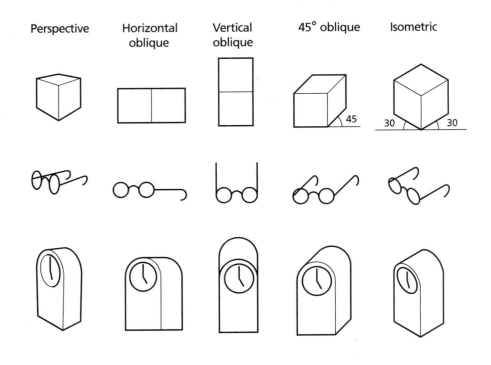

| Perspective | Horizontal oblique | Vertical oblique | 45° oblique | Isometric |

knowing the exact position of the person producing the drawing. Unfortunately they all, including perspective, have one weakness. While being able to describe regular geometric forms, they are of limited assistance when describing irregular organic forms. This is not really a major problem as the appearance of natural objects is usually understood and described in a much more pragmatic way.

To help demonstrate how the appearance of objects alters depending on which geometric system is selected, a cube, glasses, and a clock have been drawn very simply using five different systems (**11.8**).

Artists have used these systems for centuries. They are not used as formally as in an engineer's technical drawing, any more than perspective has to be exclusively theoretical to be of value in organizing a spatial drawing. The Egyptians, Greeks, and Cézanne used horizontal oblique, the Japanese, Chinese, and David Hockney (b. 1937) used 45° oblique. Indians, Persians, and Bonnard (**11.9**) used vertical oblique, while Cubism made partial use of several systems.

In both the Hokusai (**11.10**) and Hockney (**11.11**) drawings, none of the lines converge as they would in a perspective drawing, because they have used a version of 45° oblique projection. In the relatively confined spaces described, the

11.9 Pierre Bonnard, *Standing Nude on a Round Mat.* Private Collection.

In Bonnard's vertical-oblique drawing both the door and the floor are described, although they could not have been seen at the same time without considerable head movement. However, the amalgamated views strangely make the drawing more descriptive and in some ways more real than would have been possible from a single viewpoint.

11.10 Hokusai, *Hanashita-e* from the series *One Hundred Poets.* The Fitzwilliam Museum, Cambridge.

Hokusai is working within the convention that is typical of the Japanese method of describing space. None of the angled lines vanishes and they are all at the same angle. The feeling of depth is enhanced by leading the eye through the door to the second group of figures.

11.11 David Hockney, *Self-portrait with a Blue Guitar*, 1977.
Courtesy David Hockney.

Hockney has used a 45° oblique projection system, so the
edges of the objects are either horizontal or at a 45° angle.
The system works well in the relatively confined space of a
room, but would be less successful over a greater distance.
This feeling of depth, but not space, has produced a still,
decorative formality in the work.

three-dimensional relationships are easily understood and interesting images have resulted.

The main difference between a projection system and perspective is that the former does not challenge the flat surface of the paper to the same degree as perspective. Projection systems are best at describing objects in a relatively shallow space. Perspective tries to deceive the eye by attempting to transform the paper's surface and replace it with the illusion of a "window" looking into space (**11.12**). Sometimes the various methods are not completely understood, and the artist makes a totally personal drawing with a strange amalgam of systems (**11.13**).

Visual translation can be achieved via even more specialized methods of organization and representation. For example, a landscape can be translated into

11.12 Jean-Honoré Fragonard,
Genoa, Staircase of the Palazzo Balbi.
The British Museum, London.

Fragonard's atmospheric drawing of a vast interior almost creates the sensation of standing in the space. It is only made possible by the use of perspective helped by a luminous lighting effect.

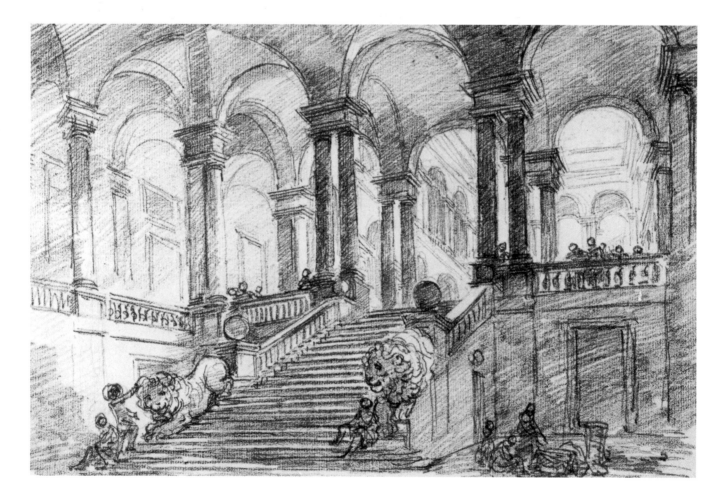

11.13 Charles Lewis, *A Bird's Eye View of the Garden of Dr. Charles Greville, 2 Barton Street, Gloucester,* late 1760s. Collection of Mrs Paul Mellon, Oak Spring Library, Upperville, Virginia.

Lewis has used a primitive form of perspective to partly organize the drawing. However, not all parts of the drawing vanish, and those that do, vanish to different eye levels and vanishing points. Although we feel we are looking down at the garden, the house is drawn looking at the front elevation, and strangely, the side of the house is showing. In spite of all its oddness it is a wonderfully informative and compelling drawing, full of rich graphic imagery.

11.14 Anonymous, *New York, Plan of Manhattan, Long Island, the Hudson River and New Amsterdam*, 1664. The British Library, London.

This map of early New York, probably an English copy of a Dutch original, is an extreme mixture of pictorial conventions. The street plan of the town is a normal map, but with the buildings represented by small illustrations. The sea is drawn quite naturalistically with sailing ships described in realistic detail.

some kind of map using different conventions that are about the organization of knowledge, not direct observation. Present-day map-makers have a range of agreed methods and symbols, but in the past maps were often a mixture of diagrammatic information and illustration, such as that seen on a mid-seventeenth century map of New York (**11.14**).

Transforming information into a diagram has even less relationship to the appearance of things. The criteria have to be based on clarity, so clear relationships, paths, color codes, and symbols are the designer's logical vocabulary. Although diagrams may seem remote from ideas about drawing, they can be visually exciting and their production has much in common with the comparative thinking needed to make a drawing.

Ideas to Explore Experimenting with drawing space and form

THIS chapter has demonstrated that although perspective probably has a dominant position in the way we attempt to illustrate space and form on a flat surface, other methods and conventions are available.

Choose a three-dimensional subject and make a number of drawings that describe its three dimensions, but not by the use of perspective. The solutions should be drawings, not just diagrams that only explain the theory of the system. You could perhaps adapt or combine systems to a more personal idiom. Below are three examples of objects drawn from a vertical oblique angle, from a 45° oblique angle, and one where these angles are mixed. Experiment with these ways of looking at an object and even try devising your own method of describing a solid object in space on a two-dimensional surface.

45° Oblique

Vertical Oblique

Mixed Systems

12

Time, Change, and Movement

IT takes time to make a drawing, but when finished it is seen complete and all at once. The conclusion should then be that a drawing is not a very useful means to convey a sense of time or movement. This however is not true, and artists use a number of strategies to overcome this supposed handicap. Several of these strategies rely on the way our brain registers time and movement. We see by scanning, which means that vision is a collection of short time spans, not static single "snapshots." Time is not remembered as an even succession of events but with some selected and emphasized, just like the parts of a drawing. All moments are not equal, and we remember those which encapsulate certain stages of a process. There is

12.1 Max Klinger (1857–1920) *Action* from *Paraphrase on the Discovery of a Glove*, 1878 (published 1881).

In this dream-like etching Klinger has chosen a series of right moments to tell the story. The swaying angles of the skaters set the scene. The urgent actions of the man attempting to retrieve the glove are in marked contrast to the oblivious calm of the woman. The past has been suggested, the present is described, and the future has a number of possibilities.

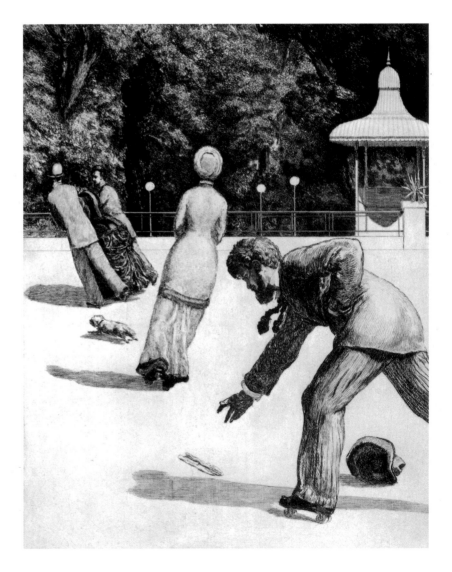

usually a particular point that has traces of the past, expectations of the future, and therefore extends the present by suggesting a complete cycle or process, not just a single moment. The problem is choosing the right moment. So identifying and understanding the whole event represented is essential if a meaningful present with a past and future is to be selected to be drawn; Max Klinger (1857–1920) catches just such a present (**12.1**).

The influence of the movie camera and Eadweard Muybridge's (1830–1904) sequence photographs in the late nineteenth century suggested an alternative to a single momentary image attempting to describe a temporal sequence. Drawings readily combine an amalgam of moments into one image so that a short period of time is described. Early in the twentieth century, the Futurists in Italy, like Umberto Boccioni (1882–1916), were particularly interested in exploring ideas about movement (**12.2**). However, Boccioni attempted more than just imitating moving pictures and was equally concerned with expressing a form of visual energy in its own right.

12.2 Umberto Boccioni, *Dynamism of a Cyclist*. 1913. Esoterick Foundation, London.

Although nominally about a cyclist, Boccioni's real interest is in producing dynamic marks that convey the energetic forces involved when cycling at speed.

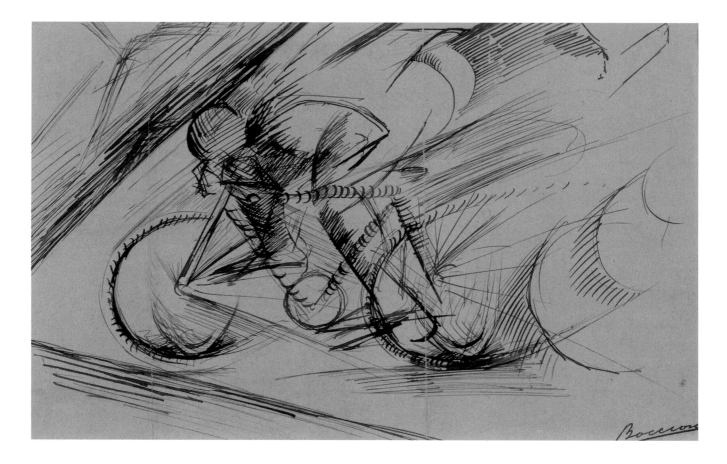

Longer periods of time, from days to years, have been described since art began. Multiple images of a series of events all appearing in a single work are fairly common and the depiction of the same person a number of times does not seem particularly strange. The life of Christ, important individuals, and historic events have often been the catalyst for their production. On a more mundane level, vast numbers of diagrams are designed every day to illustrate change and movement far more effectively than pages of words or numbers.

A drawing is an accumulation of many separate observations; however, there is no requirement that these should be made in one continuous time span. There can be quite long gaps in a drawing's production from hours to days, even years. This periodic activity is ideal for recording change on a much longer time scale. By modifying a drawing at intervals, growth, accumulation, decay, mutation, or metamorphosis can be explored, distilled, and recorded.

Five Basic Shapes

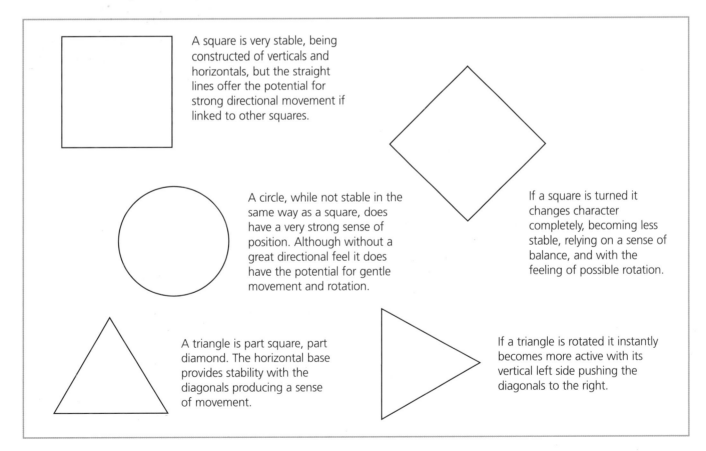

A square is very stable, being constructed of verticals and horizontals, but the straight lines offer the potential for strong directional movement if linked to other squares.

A circle, while not stable in the same way as a square, does have a very strong sense of position. Although without a great directional feel it does have the potential for gentle movement and rotation.

A triangle is part square, part diamond. The horizontal base provides stability with the diagonals producing a sense of movement.

If a square is turned it changes character completely, becoming less stable, relying on a sense of balance, and with the feeling of possible rotation.

If a triangle is rotated it instantly becomes more active with its vertical left side pushing the diagonals to the right.

12.3 Wassily Kandinsky,*Black Relationship*,
1924. The Museum of Modern Art, New York.
Acquired through the Lillie P. Bliss Bequest,
341.49

Kandinsky has only used straight lines,
circles and two small arcs in this
dramatically contrasted drawing. The two
main units are carefully related to the
enclosing square, with the black disk
creating a rather sinister presence above
the agitated forms below. The smaller,
colored, semi-transparent circle and its
small black satellite create a visual link
with the black disk. The diagonal created
by this link also contains the point from
which several shapes radiate. A number
of vertical and horizontal shapes generate
a dynamic contrast with the angled
directional wedges that aggressively
occupy the corner and oppose the black
disk's advances.

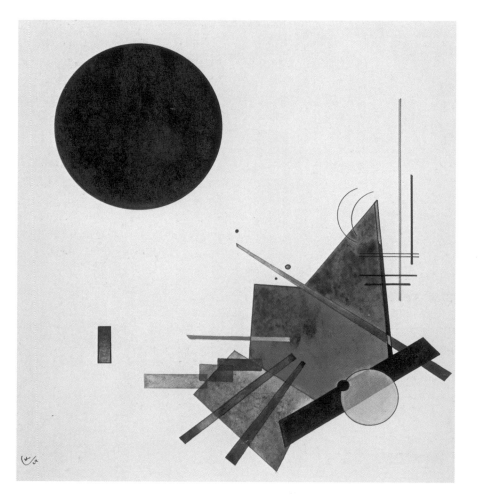

To be able to exploit all these ideas about movement and change we must be
able to utilize the inherent dynamics of marks and shapes themselves,
encouraging a drawing to become visually active. In the early twentieth cen-
tury, Russian artists such as Kandinsky (**12.3**) were particularly influential in
developing totally abstract ideas about design by using the potential that
marks provide. Before a mark is made, the rectangular sheet of paper has its
own dynamic potential. All edges are not the same. In the West, we read
from left to right so we tend to look at a drawing in the same way. This
means that the left side of a sheet of paper appears to project marks into the
rectangle, while the right side is more stable and has a more containing role.
Objects rest on the bottom edge, which is equated with the ground, and
move in from it. The top edge is less positive and forms appear to hang from
it and be less substantial.

Lines in particular are very directional and lead our eyes along their length, suggesting a real sense of movement. Vertical and horizontal lines generate a sense of stability, reminding us of gravity and balance in opposition to a horizon and the ground. Diagonal and curved lines by contrast are unstable and therefore visually more active, generating multi-directional movement. This quality is perhaps enhanced by the more physical gesture that often creates them, compared to the considered movement needed to draw a horizontal or vertical line.

Shapes can also be passive or active, and by comparing some very basic shapes their potential to imply movement becomes apparent. The examples in the table of the Five Basic Shapes might appear rather simplistic, even obvious, but when more complex lines and shapes are involved the visual potential is more diverse and subtle. With an increasing number of lines and shapes the possibilities of leading the eyes around a drawing become even more potent. If more organized relationships are constructed it is possible to have not only a general feeling of movement but definite sequences and rhythms can be suggested.

Ideas to Explore Drawing an image over time

WHEN we make a drawing of a place or object it is often felt to be a definitive statement. The assumption is that the drawing would not look markedly different if it had been made an hour or a week earlier. Is this assumption justified or do we usually select out all the transient changes that occur?

Mask off a section of a window, leaving a small rectangle, through which can be seen a section of sky and land/cityscape. Over a number of days or weeks, at various times of day and night and in all weather conditions, make a series of at least 20 small drawings. The drawings need only be a few inches across and should be the same proportion as the masked-off rectangle. Each drawing should record, in fairly simple but accurate terms, what can be seen through the window. It is best if the drawings concentrate on larger shapes and their tonal value rather than on too much minute detail. A drawing just made of lines would be unlikely to describe the full range of visual change in each drawing. Color may be a useful addition if it is carefully observed and enhances the changes in each drawing.

13

Selection and Emphasis

IT is clearly not possible or even desirable to include in a drawing everything that exists. Therefore it is essential that there is a clear idea about what the drawing is concerned with, so that certain qualities are selected and emphasized at the expense of others that are irrelevant to the idea.

In spite of being visually stimulated by a situation or idea it is sometimes difficult to be totally precise about what it is that is actually of interest. To help resolve this problem, a series of drawings which develop an idea can be more valuable than trying to solve everything in one drawing, a process demonstrated in **13.1** and **13.2**.

This process of selection does not usually require a series of drawings, but making a study to discover or clarify an idea before starting is often helpful. This exploratory study can be quite small and although it will lack detail, it should not be a scribble that has little relationship to your real intentions. The basic content, general proportions, dynamic directions, tonal areas, and textural distribution can be established so that they are an accurate visual précis of your thoughts and intentions. During a drawing it is easy to be sidetracked by irrelevant details and to forget what the real idea was and what is important to emphasize. Referring back to a small initial study can redirect the drawing

13.1 and 13.2 Theo Van Doesburg, Seven studies for the composition *Rhythm of a Russian Dance*, 1917–18 and *Rhythm of a Russian Dance*, 1918. The Museum of Modern Art, New York.

It would have been impossible for Van Doesburg to have got from the dancer to the final design in one step. The series of mutations was the only way that he could resolve his real intentions.

13.3 and 13.4 Frank Auerbach, Study for *Park Village East, Winter* and *Park Village East, Winter*, 1998–99. Amgueddfeydd ac Orielau Cenedlaethol Cymru (National Museum and Galleries of Wales).

Auerbach has made a relatively quick study for his painting Park Village East — Winter. It has helped him discover the basic structure and design of his painting by focusing on major elements, rather than confusing detail. The marks, although made with rapid gestures, are all intently seen and considered. The reasons for the drawing are strictly focused so that it does not become a vague generalized "sketch."

to what is important and relevant to your real intentions, as the comparison of a study with the finished work can reveal (**13.3** and **13.4**). With more experience, much of this preliminary assessment will probably happen in one's head by thinking carefully before starting a drawing.

Looking and thinking are the initial stages of a drawing, not mark-making. Before the first mark is made take time to decide what interests you. What is the drawing going to be about? What means will be used to express the idea? A drawing cannot be about everything, so thinking what it is not about often helps to clarify one's intentions. For example, the major interest might be to explore two-dimensional rhythms and patterns. Therefore the description of form would be less relevant, precluding a role for tone related to light, but tone would have a role describing local color to enhance the two-dimensional pattern (**13.5**).

A drawing develops in time, and this organic process is one of discovery, so deciding on the reason for a drawing does not mean that every final detail should or could be settled before a single mark is attempted. A general intention should be formulated, so that relevant questions can be asked, but the

13.5 Fernand Léger, *Face and Hands*, 1952. Museum of Modern Art, New York. Mrs Wendell T. Bush Fund, 18.53.

Léger has strictly limited the role of tone to just one property, largely excluding its ability to describe form or light. He has also been very aware of the negative shapes that the positive marks are leaving. The final result is that the white areas play an equally important role in the design as the black marks.

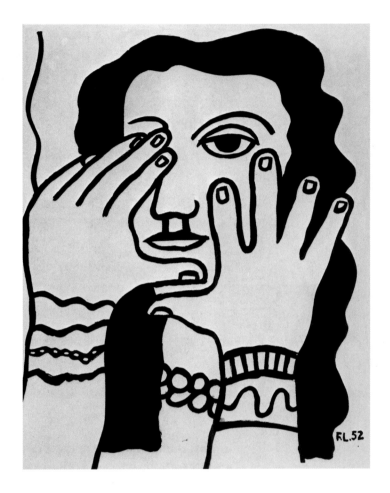

exact route to creating the drawing is not predetermined; it is discovered by responding imaginatively to perceptive observations.

Drawing does not require a constant deluge of marks; only if time for thought is allowed will the marks be informed. To leave out every other mark and think instead is a sensible formula for even a very gestural drawing such as Mondrian's *Study for the Gray Tree* (**13.6**).

A drawing can be a complete statement in its own right, but often it is part of a broader purpose. This can be initially about the purely academic discipline of learning to see and draw. Later, a drawing can be about analyzing the structure of something, recording information for use at a later date in a painting or design — compare Gilman's study (**13.7**) with the final portrait (**13.8**) — resolving a visual problem and trying out alternative solutions, or working out a design.

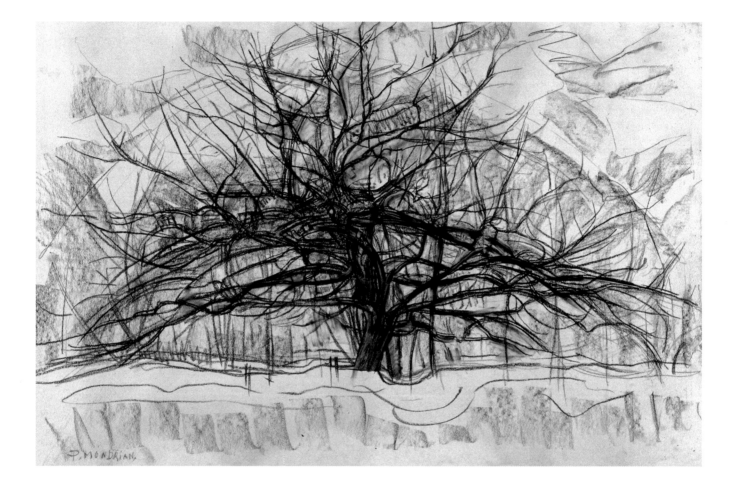

13.6 Piet Mondrian (1872–1944), *Tree: Study for the Gray Tree*, 1911. Black crayon on paper, 22¼ x 34 ins (57.7 x 86.2 cm). Gemeentemuseum, The Hague. © 2005 Mondrian/Holtzman Trust c/o hcr@hcrinternational.com

Mondrian's drawing is made of many freely drawn marks, but each one is considered and part of much larger groupings. Some produce arching movements from side to side, others spiral rhythms. They are all part of the larger tree shape and none is generalized scribble. The hundreds of separate decisions have been held together by a very clear feeling about the underlying architecture and life of the tree.

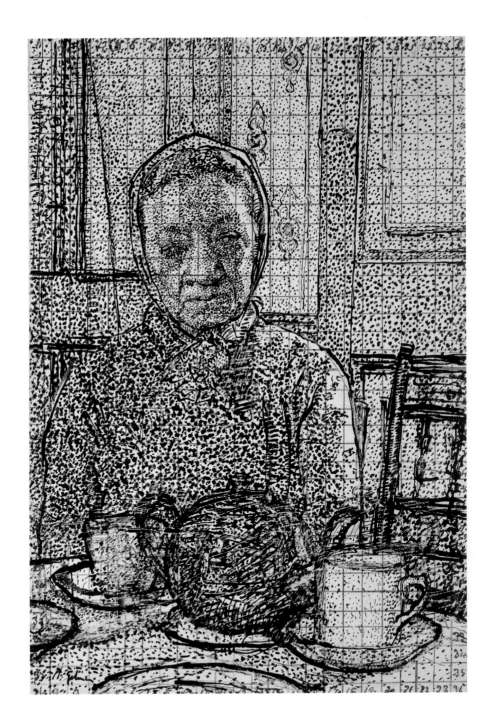

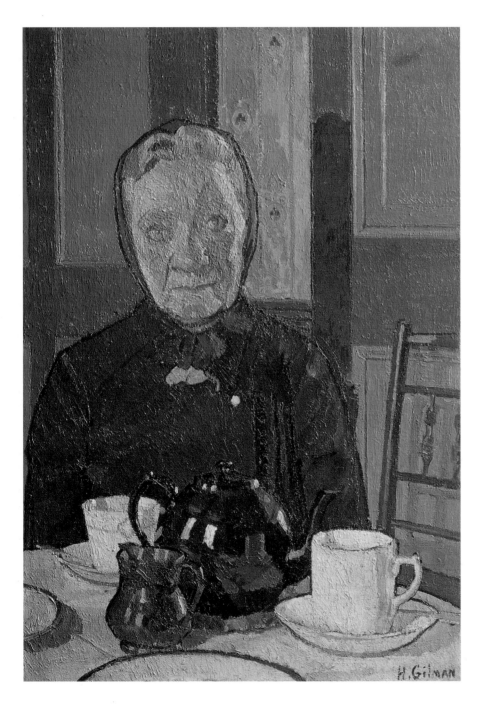

13.7 and 13.8 Harold Gilman (1876–1919), Study and painting of *Mrs Mounter*, 1916–17. Study: Ashmolean Museum, Oxford, paitning: Walker Art Gallery, Liverpool.

Gilman's preparatory study of Mrs Mounter is hardly amended in the final painting. The drawing uses lines of varying thickness to describe Mrs Mounter, the foreground objects, and the room. They are also used to organize the carefully composed design of contrasting straight and curved shapes surrounding the figure. In addition, an elaborate range of dots is used, their density carefully regulated to provide accurate information for the tonal structure of the painting.

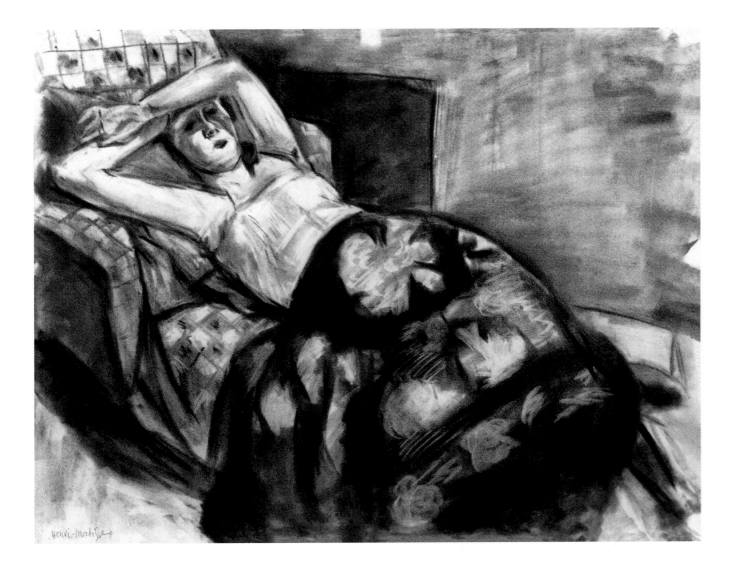

13.9 Henri Matisse, *Reclining Woman*, 1926. The Baltimore Museum of Art: The Cone Collection, formed by Dr Claribel Cone and Miss Etta Cone of Baltimore, Maryland. BMA 1950.12.52.

Matisse has drawn dynamically and quickly, but all the marks are controlled and relate to an overall idea. The volume of the sofa is solidly established to support the figure. Her arms, with the cast shadow, enclose and reveal the volume of the head. Even the flamboyant pattern on the dress rests on and implies the body and sofa beneath. The drawing looks wonderfully free, but all the marks are in fact carefully controlled without losing their vitality.

13.10 Pierre Bonnard, *Paysage au Bord de la Mer*, 1922. Private Collection.

Bonnard's drawing probably only took a few minutes to produce. He displays an amazing vocabulary of evocative marks that act as a visual shorthand. Although at first the drawing looks like a subtle scribble, on closer inspection it is full of information, and Bonnard was able to produce paintings from these almost coded marks.

Even if the reason for the drawing is a more immediate or emotional response to a situation, the act of translating these feelings still has to be via the brain and intellect. Just waving an arm, with a pencil at one end, hoping that an image equal to one's emotional response to the situation will materialize on the paper, seldom works. A drawing can be very gestural and free in its production, but gestures can still be the result of informed decisions and translation. However immediate a response is, it should still have a convincing visual equivalent; the drawings by Matisse (**13.9**) and Bonnard (**13.10**) retain their immediacy in their finished form.

Ideas to Explore Selecting and emphasizing

THE words "selection" and "emphasis" imply that the person making a drawing has decided on a set of clear intentions and therefore has criteria from which to select and emphasize. Identifying what really interests you, before starting a drawing, is clearly the way to begin, and for most drawings this scenario is the ideal. Unfortunately the ideal is not always possible. Sometimes it is difficult to be totally precise about what exactly it is that is stimulating interest. At other times it does not accommodate the possibility of discovery and change as the drawing develops. It is quite possible that by looking hard, new and unforeseen things are discovered. Then it will be important to redefine your intentions so that the selection process continues. The worst outcome is to have a confused and contradictory set of new and old ideas that make the drawing equally muddled.

Selection and emphasis are only possible if change and development are also possible, so try to cultivate a way of drawing that is flexible. The most helpful method is to draw in an exploratory way, so that having to make amendments is not a disaster. A second alternative is to make several related drawings which develop and build on each other. The two drawings below, for example, are alternate visualisations of the garden in **2.1**. The danger with this method is that it can be an excuse for a series of unresolved starts that have no real development. Whichever way you draw, it must allow for organic growth and change.

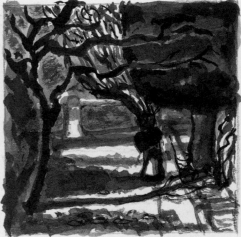

14

When to Stop

Drawings are seldom intended to be "works of art" during their production, and it is only in retrospect that they become thought of in this way. They are usually the by-product of an artist's visual inquiry or attempt to solve a problem, so this endows them with a closeness to the artist's mind and way of thinking. Drawings have enormous variety because of the infinite number of reasons for their production. Just a few marks are sufficient to express a complete idea, but, equally, many marks may be required. The time scale of production is from a few seconds to hours.

14.1 and 14.2 After Edouard Manet, *Man on Crutches* and **Stanley Spencer**, *Self-portrait*. The Ashmolean Museum, Oxford and Spencer: Williamson Art Gallery and Museum, Birkenhead.

Spencer obviously took much longer to make his drawing than the artist of the *Man on Crutches*, but both drawings are complete on their own terms. Spencer's intense and penetrating analysis of every minute detail of his face has produced a totally believable portrayal of his character. It would have been impossible and pointless for the other artist to have adopted a similar approach. The drawing would have lost its sense of immediacy produced by the dynamic and direct marks. The strength of Spencer's concern for detail is totally irrelevant to the attempt in the other drawing to catch a fleeting moment.

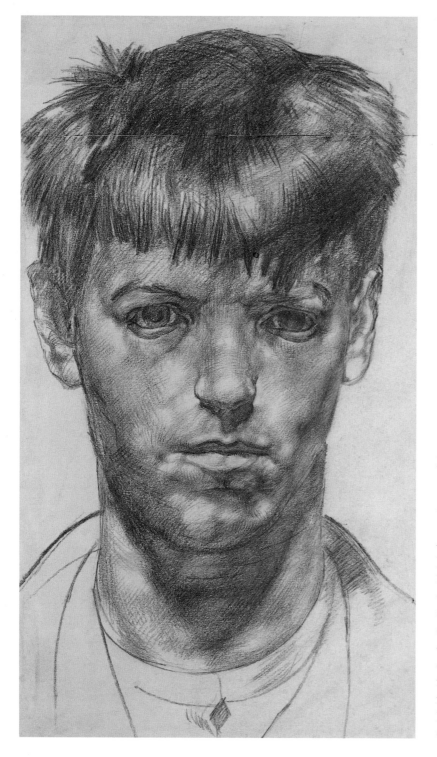

A drawing is finished when the initial idea has been translated into a compelling visual equivalent — compare **14.1** and **14.2**.

Because drawings are sometimes part of a series in a larger scheme, they can appear "unfinished," but they can be complete in a sequence of drawings exploring a common theme. The series can then be extended in a work that is not necessarily another drawing. It is not always relevant to talk in terms of a finished drawing, as several drawings contribute to the whole and may influence and be worked on at the same time; such an interrelationship exists between the numerous studies of a dancer (**14.3**) made by Edgar Degas (1834–1917) and his sculpture of the same name (**14.4**).

As a drawing progresses, an unexpected problem arises: how do you know when it is finished? "When everything has been described in great detail" is not usually the answer. As we have seen, everything is not equally important and what needs to be emphasized varies in relationship to the original intention. Just because something is there is not sufficient reason for its inclusion, and Nicholson's view of the Palästra at the ancient Greek site of Olympia (**14.5**) would not be improved by

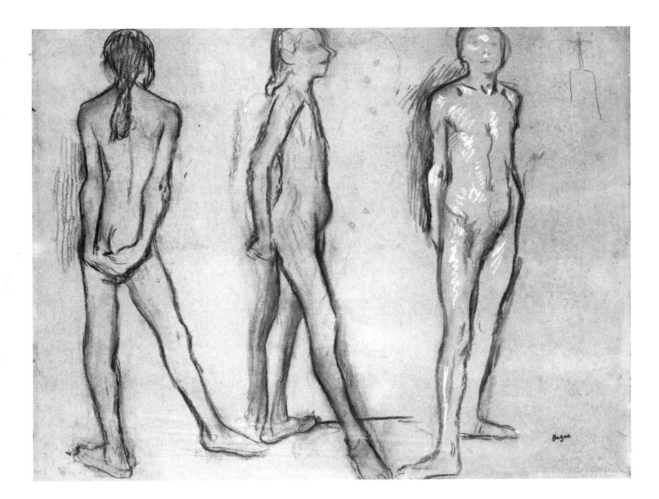

14.3 and 14.4 Edward Degas, *Three Studies of a Dancer*, 1879–80 and *Little Dancer Aged Fourteen* (*Petite Danseuse de Quatorze Ans*), c. 1920–21, from 1881 wax model. Drawing: Private Collection. Courtesy Marianne Feilchenfeldt, Zürich. Photo: Reto Pedrini. Sculpture: Joslyn Art Museum, Nebraska. Gift of M. Knoedler & Co., Inc., New York (1971.271).

Degas needed numerous studies of the dancer, from a range of angles, to provide the three-dimensional information he needed to make the final sculpture. Some drawings are just details, a head or the position of the arms, while others are of the complete figure wearing a ballet dress. These three nude studies provide basic information about the pose.

14.5 Ben Nicholson, *1961 (Palästra, Olympia)*, 1961. Aberdeen Art Gallery and Museums Collection.

This drawing obviously does not include everything and is a carefully selected statement. Nicholson has contrasted the regular man-made columns with the organic and softer quality of the tree, even changing the way he has made the marks to emphasize the difference. The result of this juxtaposition has made the tree appear more vibrantly alive than if it had been surrounded by more natural forms.

additional marks, as the artist has strictly limited the number of qualities he wishes to describe.

When a drawing nears resolution, the drawing itself becomes more important and as much the subject as the thing being drawn. Its state needs to be observed with equal intensity if it is to be made to work in relationship to the original idea. The reinforcing or elaboration of certain parts may be necessary, but equally important will be the demoting or simplifying of other areas. A drawing can be completed, not by adding, but by subtracting; evidence of this process is seen in Matisse's drawing of a strand of trees (**14.6**).

Ideas to Explore
Identifying faults

ONE of the most common remarks made at the end of making a drawing is "Oh, it was so much better before I added …." Drawings sometimes seem to take on a momentum of their own and this can lead to dynamic and exciting results. Unfortunately it can also mean that the person drawing has lost concentration and sight of the original idea, allowing totally irrelevant details and marks to be added. This problem is closely related to the previous chapter on "Selection and Emphasis." The time to stop is when the drawing reflects your original intentions, not when every last detail has been added. The problem is seldom that the whole drawing is covered with irrelevant marks, but that small parts are not related to one another and the drawing lacks unity.

When you next feel that a drawing has got worse, try to identify the areas that are unrelated to the original idea and to the rest of the drawing. Perversely, they can be the parts you have worked on most and feel reluctant to amend. Look hard and critically at a drawing at every stage to check that it is not losing its way. If you identify a problem, be willing to make difficult changes. This is the only way to learn when to stop.

14.6 Henri Matisse, *Group of Trees at L'Estaque*, 1884. Musée National d'Art Moderne, Centre Georges Pompidou, Paris.

Matisse did not think that a drawing is finished by just adding more marks. He has completed this drawing of trees by removing earlier work so that the basic shape and rhythms are emphasized. The erasing would not have been a single isolated stage in the drawing, but would have been part of the drawing process, with some marks removed and then others added as the drawing required. It certainly was not carried out right at the end to "tidy up" the drawing.

15
Visual Fluency

INEVITABLY the structure of a book dictates that ideas and information are presented sequentially. The activity of drawing cannot be isolated into these neat sections, because it is an amalgam of ideas, responses, and processes occurring concurrently. Lacing together the various strands of information is essential if each part is to make sense. The excitement and stimulation of discovering and recording the visual world or being able to convert ideas into a drawing is an amazing ability. It is a kind of alchemy having the skill to transform an idea or observation into just a few marks that are understood as their equivalent. This book provides a framework of knowledge and suggests a few paths to follow to achieve this skill, but learning to draw also requires commitment, concentration, practice, and, most of all, enthusiasm.

Finally, drawing is not about imitation; it is about transforming reality or ideas into vital and imaginative visual equivalents. Learning how to decide what questions to ask and how the answers can be given accurate visual form is how a drawing is made. Different questions and how they are asked will produce completely dissimilar drawings. All three portraits (**15.1**, **15.2**, and **15.3**) look different. However, one is not better than another; it is just that each artist had a unique and personal idea and therefore each asked their own set of questions.

While some people clearly have more innate ability than others, everybody can learn to think visually and acquire basic drawing skills. Like any new language, the language of drawing takes time, thought, concentration, and practice, but drawing is not a mysterious gift bestowed on only a chosen few. The gifted also have to learn to draw (**15.4**).

Languages allow thoughts to flourish, be clarified, and shared. Drawing is one of the most subtle, versatile, and complete languages available. It is well worth learning.

15.1 Michelangelo Buonarroti, *Portrait of a Young Boy*, c. 1532. British Museum, London.

This exceptionally sensitive drawing, bathed in a soft and subtle light, reveals every nuance of form. Although the drawing is intently observed, Michelangelo has also conformed with the conventions of the High Renaissance and created an idealised portrait of the boy.

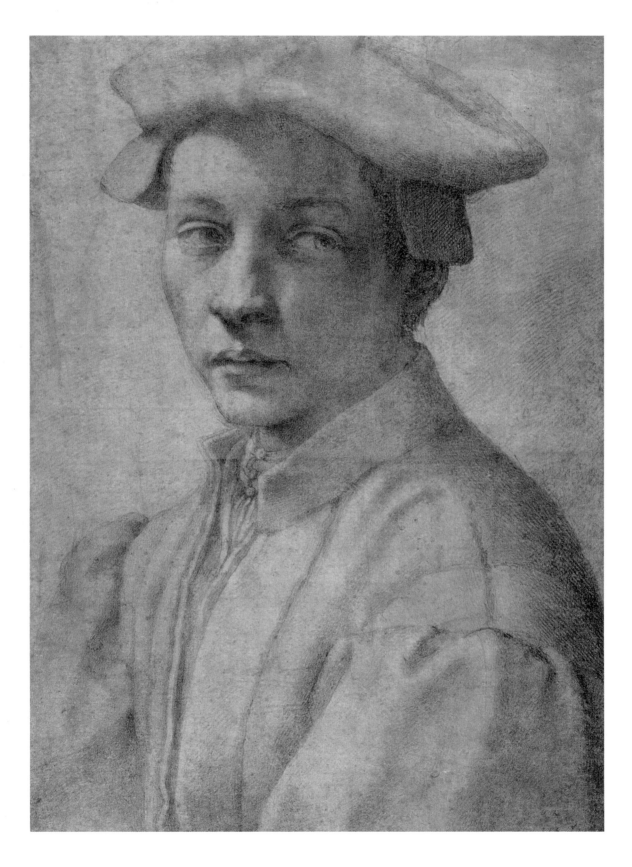

15.2 Amedeo Modigliani,
Head – Raimondo, c. 1915. The
Barnes Foundation, Pennsylvania.

In spite of being extremely
stylised, Modigliani's portraits
always describe the essence
of a person's character. The
design of this drawing
typically exploits sensuously
curving lines and strongly
elongated shapes. Modigliani
was particularly interested in
African sculpture and this
influence has produced a
simplified mask-like quality
to the head.

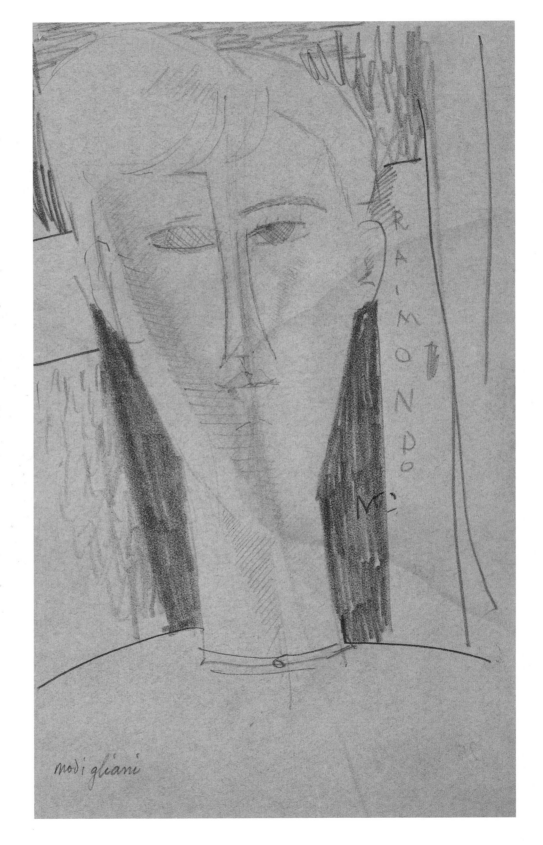

15.3 Frank Auerbach, *Jake*, 1990. Private Collection.

This etching of his son illustrates Auerbach's awareness of
past traditions and contemporary idioms. The intensely restless
line conveys a compelling feeling of energy, but also describes
the head's structure and geometry in a quite classical form.

15.4 Pablo Picasso, *Frenhofer at work on his "Unknown Masterpiece,"*
illustration for the story "Le Chef d'Oeuvre Inconnu" by Honoré de Balzac.
The Stapleton Collection.

Picasso's engraving concisely conveys the essence of making a
drawing. The imagination is stimulated by looking at the world,
and by using the language of drawing the artist is able to
transform his ideas into a unique visual equivalent.

16

More ideas to Explore

WHILE it is perfectly possible to learn how to draw privately, throughout history help and advice have speeded the process. So the first practical suggestion is to supplement the contents of this book by enrolling on an art or design course that includes a serious and encouraging attitude towards drawing. A full-time course is the ideal, but this is not always possible or available. Alternatively, a part-time course or drawing class can be extremely helpful and successful, particularly if combined with regular private study. As well as tuition and additional facilities, seeing other students' work is often stimulating.

Looking critically at things and making visual assessments is the start of drawing, so another advantage of joining a course is that they often include life-drawing classes. It is important to remember that it is not the Renaissance now, and life drawing is not some separate drawing activity that by itself holds the magic key to the art of drawing. It is just a valuable part of the process of learning to see. However, life drawing can be a wonderfully flexible vehicle for learning how to make all kinds of visual judgments. We also have a natural empathy with the human figure, so drawing a person is usually more involving than drawing a turnip — not that I am against turnip drawing. There are thousands of examples of drawings of the human figure from every period of history, and this unique archive is an invaluable source of information and inspiration (**5.1**). Because of this, several earlier sections of this book use the figure as an example when discussing how we learn to see.

As life drawing is not always an option, there are plenty of alternatives which can be used to gain basic visual skills. Plants, shells, bones, buildings, machines, still-life groups, dolls, landscapes, etc. — and of course a mirror — all provide sources for visual analysis and discovery.

Whatever it is that you use as the subject matter of your observations, the most important first step is learning the difference between really seeing and just recognizing. The ability to make basic visual judgments and the acquisition of a comparative way of looking are fundamental to learning to draw. So the key follow-up idea is to look, analyse, and draw as much as possible.

The "Ideas to Explore" in each chapter have provided suggestions for related practical work. However, ideas for follow-up projects do not always fit neatly into topics covered by just one chapter. The suggestions in this final section deal with ideas discussed in several chapters, helping you to make connections between chapters, and reinforcing a comprehensive understanding of the whole drawing process. The following suggestions do not form a rigid course, but are proposals to encourage personal exploration of visual ideas via drawing.

1 Selecting Visual Problems

Make a series of drawings of the same object or situation, with each drawing emphasizing a different visual problem. For example, select aspects that will emphasize flat pattern by exclusively using lines of the same thickness and with no use of shading. Then again use lines but of different widths, and notice if a relatively slight change alters the meaning of the drawing. In contrast make some tonal drawings that describe the three-dimensional nature of the objects. See if altering the lighting conditions changes the appearance of the objects and by casting shadows or pinpointing the light are they even camouflaged? Use different drawing materials and change the size of your drawing from as small as a postage stamp to large enough for quite gestural marks to be made. Make a drawing that is very selective and tries to describe what is fundamental about the objects in only 25 marks.

Often one of the biggest problems in learning to draw is agreeing to abandon bad habits, such as perceiving drawing as a process of copying, rather than thinking and translating. Therefore the main objective for this series of drawings is not to have preconceived ideas, but be willing to experiment with new visual problems in new ways.

2 Visual Analysis and Reasoning

Decide on two different positions from which to draw an object or figure. Then make a drawing observing from one position, but imagine you are looking from the other position. When you have finished your imagined drawing move to the second place and see how well you understood the object by thinking about it rather than making direct observations. It is quite interesting to correct the drawing from the "correct" position.

3 Ways of Seeing

Find a room, garden, or some other reasonably enclosed space that is too big to be seen completely without turning your head. Devise a way of drawing that allows you to describe the whole space in

one drawing and accommodates the fact that you will have to move your head and will have several viewing positions to combine. The drawing should include your feet and what is above your head.

4 Proportions and Transitions

This suggestion is more of an extended exploration than an individual drawing. It is a sequence of visual exercises that progress from simple to complex and need to be worked through methodically in the early stages to gain full benefit. Although all the stages require imagination, the latter part is much more open-ended and encourages personal exploration which can be extended over hours, even days. A simple format is proposed, so that progress is reasonably rapid, particularly at first, but this does not mean that the underlying ideas are visually unsophisticated.

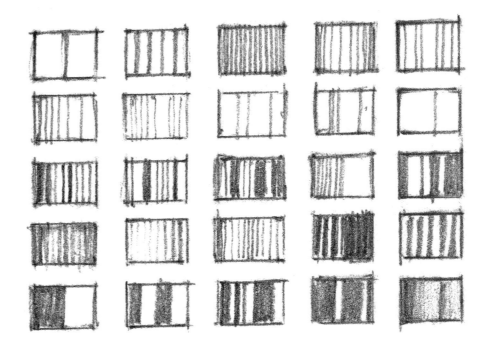

Work on reasonably large sheets of paper and mark out rows of small rectangles, 3 in by 2 in (8 cm by 5 cm). Later stages might benefit from a slightly larger format. A few small diagrams are included to explain possible layouts and methods of working. The diagram opposite is not intended to be a prescription for work, but just a few visual clues to augment the words.

The intention is to explore how many different kinds of vertical divisions can be made in the rectangles. There is no upper limit, but tens if not hundreds are possible. Work methodically and, where relevant, build on previous experiments, so that a series is produced, rather than "one-off" designs. The following list contains suggestions of ways that you might divide your rectangles:

● Use lines of the same thickness at regular intervals.

● Use lines of the same thickness at irregular intervals. They can be random clustered, in repeat patterns, or make ripples or rhythms.

● Use lines of different thickness, but at regular intervals, and then also vary the intervals.

● Vary the tones of the lines from black to pale gray, keeping their divisions regular as with the diagram below. Then also change the positions and then also the thickness of the lines.

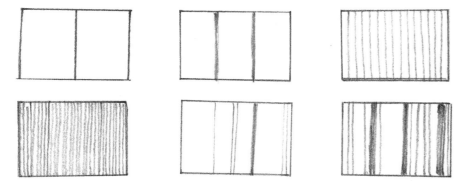

● Now instead of using lines, fill in the areas between lines so that you are now only dealing with shapes. Repeat the same procedure as described for experimenting with lines, but now with solid areas that touch one another instead.

● Having completed another series by only using shapes it is possible to move on to more visually varied possibilities.

● Start modifying the edges of the shapes so that soft, hard, broken edges subtly alter the appearance of the intervals.

● Give the strips a texture or surface quality by using different media or including collage.

● Try to create a sense of spatial difference between the vertical elements.

● Attempt to imply form or an illusion of overlap.

● Introduce some warm/cool contrast by using blue/yellow grays.

● Use angled and curved vertical divisions.

● Adjust the top and bottom edges of the rectangle in relationship to the vertical shapes as in the diagram opposite.

● Combine two or more of the previous strategies to produce more complex solutions.

● Start using color.

● Produce intervals based on mathematical or musical progressions or rhythms.

● Translate an observed situation, for example fences, buildings, trees, a row of upright objects, etc., into a set of intervals by just drawing their vertical components.

While this list is fairly comprehensive you will no doubt be able to invent other strategies.

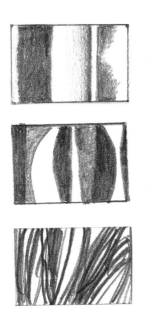
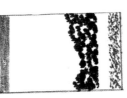

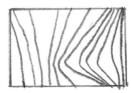

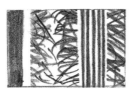

5 Movement

Ask a model to walk slowly across a room, holding each step for
two or three minutes. Drawing, rapidly record the progress across
the floor starting each new drawing in the last footprint. There is
not time to draw irrelevant details; the main concern must be to
describe rhythm and movement. Two or three minutes is longer
than you may think, so although your marks need to be dynamic,
there is time to think, and not scribble. Use a reasonably large
sheet of paper, and start at one side to allow the drawing to follow
the model's progress.

6 Time and Change

Make a drawing that describes an event that lasts a period of time.
It can be as brief as a few seconds, to a lengthy process lasting
hours or days. It could be an observed drawing recording how
objects on a table top are moved and change over a period of time,
how a plant grows or decays over a number of days, or the way a
park bench is occupied over a few hours. It might be a rapid action
or movement like throwing or dancing. The drawing could be a
combination of events described in a single format, but occurring at
different times. A single drawing could encapsulate a period of time

by inferring a past and future in a depiction of the present. It might be useful to research your ideas in a number of ways before combining it into a final drawing.

7 Synthesis

Make a number of drawings of an object from different positions so that you build up a clear understanding of its structure and appearance. Finally combine your knowledge of the object into one drawing that gives a more comprehensive idea of the object than could be achieved from a single viewpoint. You will probably need to experiment with possible alternatives, using your preliminary drawings as reference, before arriving at the most satisfactory solution.

8 Relationships

Collect a number of small objects such as stones, buttons, pulses, sweets, keys, etc. Choose one type of object and make a series of drawings, starting with a single item, then add a second, third, and so on until the area of the drawing is totally filled. The spaces between the objects and finally their relationship to the edge of the drawing should be considered with each addition. The drawings should not be too large and the same rectangle should be common to all the drawings. Be aware of underlying relationships and rhythms that could be exploited in the design.

9 Scale

Imagine you are an ant and because of your unusual drawing ability you wish to record the world in a series of drawings. Not only would relatively small things become immensely large, but they would also become unrecognizable because they could not be seen as complete entities anymore. The page of a newspaper would cease to be understood as a rectangular sheet of paper containing words and photographs. It would be seen as an extremely large flat area with strange surface markings disappearing in all directions. A shower would resemble Niagara Falls, a beefburger a large building, and a pencil line would be

as wide as a path. Textures and surfaces would change their character, becoming more pronounced or rough. You will need to think differently and not assume you know what things look like from a human scale. An ant's world is different.

10 Mirrors

One of the most available and involving subjects is to draw oneself or other objects in a mirror. Although the image in a mirror is nearly identical to the object producing the image, it often appears more real. This is partly because the image is isolated from its surroundings and our attention is more focused. The image is also much smaller than expected, again heightening its quality. We are all interested in how we look, and drawing ourselves usually commands our particularly careful scrutiny, often resulting in finely observed drawings, of which Samuel Palmer's self-portrait is a good example (**7.7**).

Using two mirrors to obtain a different reflection or making a dark mirror by painting one side of a piece of glass with black paint are other variations that could be considered.

11 Translation, Metamorphoses, and Symbols

Produce a series of drawings that transform the real appearance of things into a sign or symbol. These symbols will be used as direction signs at either a zoo, a sports center, or a museum and indicate clearly what each section of the place contains. Try to work in an ordered way; in other words, follow a design process.

a. *Identify the Problem*
Define exactly what your design needs to do. It must replace words, be legible, and be easily understood.

b. *Research*
Collect as much information as you can about your chosen subject. Produce informative preliminary drawings. These should not be designs, but well-researched studies that will provide visual starting points for later development.

c. *Proposed Solutions*
Produce a large number of alternative ideas/possible solutions
in a rough form. The main intention is to transform a naturalistic image of an animal, sport, or object into an easily recognizable symbol that is also visually imaginative.

d. *Final Design*
Make drawings of your final choices. Do not rush to this stage; the time spent on the earlier parts is when you digest ideas and your imagination is free to operate. This stage is about refining your final thoughts into interesting, legible, and well-designed images.

12 Scale and Context

Draw some familiar objects such as fruit, kitchen utensils, ornaments, toys, etc., but place them in a range of different contexts that are of a completely different scale or are totally unfamiliar and unexpected. Try to make your drawings look as real as possible to heighten the incongruous nature of the situation.

13 Marks, Transitions, and Visual Memory

Go for a walk and try to remember the many sensations and qualities that you experience. On your return, make a drawing using different types and qualities of marks and transitions to reflect your experiences on the walk. Your drawing may contain some figurative imagery or be entirely non-figurative. It could be sequential, like the walk, or could just create a general impression of the aspects of the walk that remain strongest in your memory.

As well as responding to the physical qualities of your walk, was the ground soft, hard, broken, or smooth? Were the surroundings natural or man-made, open or enclosed, flat, undulating, or hilly? Also comment on more amorphous qualities such as the weather, the time of year, the time of day, the type of light. Was it calm or busy? Were there any smells or noises? You will remember your walk unevenly, with some quite small events having more significance than some major items. The focus of your drawing should be the translation of your reactions to a series of events into purely visual equivalents such as marks, contrasts, and transitions. It is probably a good idea to experiment on a rough sheet of paper with marks to see if they stimulate the right response before working on the main drawing.

Similar drawings could be made that encapsulate your reaction to a meal, a room, or a conversation.

Glossary

AERIAL PERSPECTIVE A form of perspective that relies on the fact that objects close to an observer appear clear and sharp while atmospheric conditions often make those in the distance appear less distinct, with blurred outlines and desaturated color.

AXONOMETRIC (from Greek *axon* axis + *metron* measure) Of a (system of) non-perspective pictorial representation of a three-dimensional object, which contains a true plan with the three principal axes inclined at an angle to the plane. *Compare* isometric.

CHALK A drawing instrument comprising powdered calcium carbonate molded with various gums into the shape of a stick. *See also* pastel.

CHARCOAL A drawing instrument made by charring thin pieces of wood in a furnace. It can also be in the form of *compressed charcoal*, which is powdered charcoal mixed with a binding substance and compressed into sticks.

COLLAGE (from French *coller*, to glue or stick together) An art work comprising pieces of paper, fabric, and/or other materials glued onto a flat surface, sometimes combined with drawing or painting.

CONE OF VISION In perspective theory, an imaginary cone with its apex at the eye of a static observer and its sides defining that observer's field of vision.

CONTÉ CRAYON One of the drawing implements invented by the Frenchman Nicolas-Jacques Conté (1755–1805), made of pigment in a waxy base molded into a small stick.

CONTOUR LINE The line that follows the perceived edge of a three-dimensional form in a drawing or painting.

COPYBOOK In the history of art, a book compiled by a master artist containing specimen drawings of figures, motifs, etc. for his pupils to copy.

DESATURATED COLOR A color lacking intensity or purity and tending towards gray. Desaturated colors are seen in distant features of a landscape, which look bluer than those close at hand because the red light is scattered more than the blue in the intervening atmosphere – an effect exploited in aerial perspective.

FIXATIVE A thin liquid that can be sprayed onto the surface of a drawing made in a medium that is liable to smudge (such as charcoal) so as to "fix" it and protect the work from damage.

FORESHORTENING In perspective, the effect achieved by exaggerating the size of the elements in the picture that are nearest to the viewer and by correspondingly reducing the size of the elements that are farther away.

FROTTAGE (from French *frotter*, to rub) (An artwork produced by) the process of rubbing a sheet of paper that has been placed on a marked or textured surface with a soft pencil or crayon in order to reproduce the markings or texture.

GOLDEN SECTION The proportion that is consistently felt to yield a most harmonious ratio of divisions of a straight line or plane figure. This golden ratio is 1.618 to 1 or approximately 8 to 5. Another way to express this is that in the visual relationship of unequal parts of a whole the most satisfying division is created if the smaller element of a line or area is in the same proportion to the larger as the larger is to the whole.

GOUACHE An opaque water-based paint.

GRAPHITE A soft, blackish form of carbon that is mixed with clay and used to make pencils and crayons of varying degrees of hardness.

GROUND PLANE In a two-dimensional work of art, the level on which the objects in the drawing or painting rest.

HATCHING A drawing technique in which a number of fine, closely spaced, and usually parallel lines are used to create a tonal area. *Cross-hatching* is a development of this in which other lines are drawn to intersect the hatching.

HIGHLIGHT In a drawing or painting, the part of a shape or surface on which, from the viewer's position, the greatest amount of light is reflected; this is represented by the lightest tonal values.

HORIZON LINE In perspective, the horizontal level opposite the observer's eyes when looking straight ahead. This may or may not coincide with the actual horizon, where earth and sky appear to meet.

INDIA(N) INK A permanent black ink made from lampblack pigment in a resin binder, used as a drawing medium.

ISOMETRIC (from Greek *isos* equal + *metron* measure) Of a (system of) non-perspective pictorial representation of a three-dimensional object that measures height, width, and depth on the same scale; particularly used in architectural and technical drawing. *Compare* axonometric.

LINEAR PERSPECTIVE *see under* perspective

LOCAL COLOR In a black and white drawing, the implication of the color of objects achieved by giving the darker/lighter colors a tonal value similar to the darkness/ lightness of the real color.

PARALLAX An optical effect that makes it appear that a change in the position of the observer results in the change in the position of the object observed.

PASTEL A colored chalk made of powdered pigment bound together with a water-based gum and molded into small sticks.

PERSPECTIVE A system by which an illusion of three-dimensionality is created on a two-dimensional surface. *Linear perspective* is the formal system for drawing the way that an object at a distance from an observer appears smaller than a similar object close at hand; it is based on the visual phenomenon that parallel lines receding into the distance appear to converge at a vanishing point on the horizon line. *One-point perspective* is the most widely found version, but *two-* or *three-point perspective*, using more than one set of converging parallel lines, produces more complicated illusions of depth. *See also* aerial perspective.

PICTURE PLANE An imaginary transparent surface placed between the observer and the object being drawn, the position of which determines the size of the drawing: placed near the object, it produces a large image, near the eye a smaller one. For convenience, the picture plane is often imagined at about arm's length or the same distance as the actual drawing surface from the eye thus making the imagined picture plane and the drawing the same size. *See also* sight size.

ROUGH IN Making preliminary marks in an attempt to establish the foundations of a drawing. Such marks are only helpful if they are executed with careful consideration of the fundamentals of what the drawing is about, and in any case will probably have to be amended as the drawing takes shape.

SCALE In a work of art, the size of a depicted object relative to its real or actual size; also the sizes of depicted objects relative to each other. Scale is often related to the dimensions of the human figure.

SIGHT SIZE The relationship that occurs when the imagined picture plane and the drawing are the same size, thus allowing measurements to be taken at arm's length from the eye that are the same size as the drawing. Distant objects appear unexpectedly small, but this true sight size is the most natural size to draw.

SIZE CONSTANCY In drawing, an effect related to perspective. Size constancy has the effect, when we are drawing, of making us underestimate the difference in size between near and far objects, but the brain does not make this size compensation when looking at the illusion of space in a flat drawing.

SPACE In a two-dimensional work of art, the suggestion of the three-dimensional void in which elements of the picture exist and relate to each other. Since space itself cannot be drawn, only the relationship of objects, surfaces, or marks in space can be described. Perspective, size constancy, texture gradients, position on a ground plane, overlap, and aerial perspective are visual phenomena that enable us to make sense of space in the actual world and in a work of art.

STILL LIFE A painting or drawing the subject of which wholly (or mainly) consists of inanimate objects, usually an assemblage of flowers, fruit, and/or household items.

TEXTURE GRADIENT The visual phenomenon by which textured surfaces (e.g. a grassy field, a pebbly beach) appear rough at close quarters and become progressively smoother to the eye as the surface recedes into the distance. Exploiting texture gradient enables an artist to lend depth to a picture.

TONE In a drawing or painting, the relative darkness or lightness of a color or area. Different kinds of *tonal value* need to be distinguished, relating to color, form, and light. To achieve an harmonious and coherent effect a single *tone scale* should be used across a whole picture (rather than describing every individual object with a complete black to white range of tonal values).

VANISHING POINT A point on the horizon line at which parallel lines apparently converge and vanish. There may be several vanishing points in a picture, but generally the most important one is the central vanishing point, the position on the horizon directly opposite the observer's eye which is the point at which all lines at right angles to the horizon appear to vanish.

WASH A thin transparent layer of watercolor or ink applied over a drawing.

WATERCOLOR A transparent water-based paint.

Further Reading

As all artists draw it is impossible to recommend a book on every artist's drawings. This list is therefore limited to a few general books on drawing and perception.

Albers, Josef, *Despite Straight Lines*, New Haven, Conn: Yale University Press, 1961.

Clarke, Kenneth, *The Nude*, London: John Murray, 1956.

D'Amelio, Joseph, *Perspective Drawing Handbook*, New York: Van Nostrand Reinhold, 1984.

Dubery, Fred and Willats, John, *Drawing Systems*, New York: Van Nostrand Reinhold, 1972.

Dubery, Fred and Willats, John, *Perspective and Other Drawing Systems*, London: The Herbert Press, 1972.

Gombrich, Ernst, *Art and Illusion*, London: Phaidon, 1960.

Gombrich, Ernst, *The Image and The Eye*, London: Phaidon, 1982.

Gregory, Richard, *Eye and Brain*, London: Weidenfeld and Nicholson, 1966.

Gregory, Richard, *The Intelligent Eye*, London: Weidenfeld and Nicholson, 1970.

Hold, Michael, *Mathematics in Art*, New York: Van Nostrand Reinhold, 1971.

Kandinsky, Wassily, *Point and Line to Plane*, New York: Dover Publications, 1979.

Klee, Paul, *Pedagogical Sketchbook*, London: Faber and Faber, 1968.

Mayer, Ralph, *The Artist's Handbook of Materials and Techniques*, 5th ed., London: Faber and Faber, 1991.

Mulins, Frederich, *Drawing Ideas of the Masters*, London/Tucson, Az: Phaidon/HP Books, 1981.

Vance, Studley, *The Art and Craft of Handmade Paper*, New York: Van Nostrand Reinhold, 1977.

White, Gwen, *Perspective*, London: Batsford, 2002.

Index

Picture credits

Laurence King Publishing Ltd, the author and the picture researcher wish to thank the institutions and individuals who have kindly provided photographic material for use in this book.

Front jacket (main image). Detail of **7.6**.

Page 2. Frontispiece. See **15.3** for full caption. © The Artist. Photo: The Bridgeman Art Library.

1.1 Bull. Lascaux cave, *c.* 12,000 BCE. Pigment on limestone.

1.2 Nefertari and Isis. Tomb of Nefertari, Thebes. *c.* 1297–1185 BCE. Mural painting. Nina de Garis Davies copy of wall painting. Ashmolean Museum, Oxford.

1.3 Paul Rand (1914–96). *IBM*, 1981. IBM is a registered trademark of International Business Machines Corporation.

1.4 Cattle and Boats on the Nile. Private tomb of Kaemankh, Giza, *c.* 2650–2135 BCE. Mural painting. Nina de Garis Davies copy of wall painting. Ashmolean Museum, Oxford.

1.5 Frieze of Geese. Mastaba (tomb) of Het, 2630 BCE. Mural painting. Nina de Garis Davies copy of wall painting. Ashmolean Museum, Oxford.

1.6 Villard de Honnecourt (fl. 1190–1235). *Snail and Hungarian Soldier*. Pen and ink on paper. Bibliothèque d'École des Beaux-Arts, Paris. Photo: The Bridgeman Art Library.

1.7 Albrecht Dürer (1471–1528). *Figure of a Man Shown in Motion*, 1528. Pen and ink on paper. Sachische Landesbibliothek, Dresden.

1.8 Leonardo da Vinci (1452–1519). *Skeleton of an Arm*, *c.* 1528. Pen and ink with wash. Royal Library, Windsor. Photo: The Bridgeman Art Library.

1.9 Antonio Pisanello (c. 1395–1455). *Monkey*. Taken from the Vallardi Album, 15th century. Pen and ink on paper. Musée du Louvre, Paris. Photo: The Bridgeman Art Library.

1.10 Michelangelo Buonarroti (1475–1564). *A Battle Scene*, 1500–55. Pen and brown ink, 7 $^7/_8$ x 9 $^7/_8$ in. (17.9 x 25.1 cm). The Ashmolean Museum, Oxford.

1.11 Jean-Auguste-Dominique Ingres (1780–1867). *Jean-François-Antoine Forest*, 1823. Graphite on paper, 5 $^3/_8$ x 8 $^7/_8$ in. (13.5 x 22.4 cm). The Ashmolean Museum, Oxford.

1.12 Gustave Courbet (1819–77). *A Young Boy Holding a Basket of Stones*, 1865. Black crayon on paper, extensively stumped, 11 $^3/_8$ x 8 in (29.5 x 21.1 cm). The Ashmolean Museum, Oxford.

1.13 Luke Fildes (1843–1927). *Study of a Plaster-cast Foot*, 1865. Black and white chalk on buff paper, 15 3/8 x 15 1/2 in (39.4 x 40 cm), The Victoria and Albert Museum, London.

1.14 Egon Schiele (1890–1918). *Self-portrait*, 1911. Pencil and watercolor on paper, 19 1/2 x 12 5/8 in (49.5 x 32 cm). Private collection. Photo: The Bridgeman Art Library.

1.15 Edward Hopper (1882–1967). *Study for the painting Gas*, 1940. Conté, crayon, charcoal and chalk on paper, 15 x 22 1/8 in. (38.1 x 56.2 cm). Josephine N. Hopper Bequest. The Whitney Museum of American Art, New York.

1.16 Paul Cézanne (1839–1906). *Self-portrait*, 1888. Pencil, 8 1/2 x 4 3/4 in. (46.2 x 35.2 cm). The Art Institute of Chicago. Gift of Walter S. Brewster 1948.291

1.17 Franz Kline (1910–62). *Corinthian II*, 1961. Oil on canvas, 6 ft 7 7/8 in x 9 ft (202.2 x 272.4 cm), © Museum of Fine Arts, Houston. Bequest of Caroline Weiss Law. © ARS, NY and DACS, London 2005. Photo: The Bridgeman Art Library.

2.1 Keith Micklewright (b. 1933). *Garden*, 1990. Pencil on paper, 9 x 9 in (22.4 x 22.4 cm). Collection of the artist.

2.2 William Hogarth (1697–1764). *The Fisherman or False Perspective*, 1753. Engraving. British Museum, London.

2.3 Sir Alec Issigonis (1906–88), First Concept of Front-wheel Drive, Transverse-engine Vehicle. 1956. Pencil on paper, 13 x 9 in. (32.9 x 25.3 cm). Collection of Designer.

2.4 Morris Hirschfield (1872–1946). *Two Women in Front of a Mirror*, 1943. Oil on canvas, 51 1/5 x 59 1/2 in (130 x 151 cm). Peggy Guggenheim Foundation, Venice. Photo: The Bridgeman Art Library.

Page 39 Samuel Palmer (1805–81). *Page from the artists' notebook*. Pencil, 4 3/4 x 7 1/2 in (12 x 19 cm). Ashmolean Museum, Oxford.

Page 40 John Constable (1805–81). *Page from the artists' notebook*. Pencil, 3 1/2 x 2 1/2 in (8.89 x 6.35 cm). Victoria and Albert Museum, London.

4.3 Vincent Van Gogh (1853–90). *View of a Tile Works*, 1888. Pen and ink and graphite on paper, 23 1/8 x 17 1/8 in (58.8 x 43.5 cm) framed. The Samuel Courtauld Trust, The Courtauld Institute Art Gallery, London.

4.4 Giorgio De Chirico (1888–1978). *Solitude*, 1917. Pencil on paper, 8 3/4 x 12 1/2 in (22.7 x 32.3 cm). Private collection. © DACS 2005. Photo: The Bridgeman Art Library.

4.5 Rembrandt van Rijn (1606–69). *Study of a Young Man Standing*, Pen and wash. Albertina Museum, Vienna.

4.8 Keith Micklewright (b. 1933). *Seated Figure*, 1970 and diagram for *Seated Figure*. Drawing: Pencil on paper, 10 1/3 x 7 1/2 in (26.6 x 19 cm). Collection of the artist.

4.11 Jean-François Millet (1814–75). *Two Sleeping Figures*, study for *La Meridienne*, c. 1865. Charcoal on paper. The Ashmolean Museum, Oxford.

4.12 Alberto Giacometti (1901–66). *Diego Seated*, 1948. Oil on canvas, 31 3/4 x 19 1/2 in (81 x 50 cm). Robert and Lisa Sainsbury Collection, University of East Anglia, Norwich. Photo: James Austin.

5.1 Paul Cézanne (1839–1906). *Male Nude*. Charcoal on paper. The Ashmolean Museum, Oxford.

5.2 Richard Diebenkorn (1922–93). *Untitled (Ocean Park)*, 1977. Acrylic, gouache, watercolor, cut-and-pasted paper, and pencil on cut-and-pasted paper, 18 1/4 x 32 3/4 in (47.6 × 83.2 cm). The Museum of Modern Art, New York. Purchase.

5.3 Richard Diebenkorn (1922–93). *Seated Woman, Patterned Dress*, 1966. Watercolor, charcoal, gouache, and conté crayon, 31 x 24 1/4 in (78.7 x 61.6 cm). The University of Albany, State University of New York.

5.4 Le Corbusier (1887–1965). *The Modulor* as in *Le Corbusier, The Modulor: an harmonious measure to the human scale, universally applicable to architecture and mechanics*, London, 1954.

6.3 Paul Cézanne (1839–1906). *Male Nude*, c. 1863. Black chalk on paper, 19 1/2 x 12 1/5 in. (49.3 x 31 cm). The Fitzwilliam Museum, Cambridge. Photo: The Bridgeman Art Library.

6.4 Giovanni Francesco Barbieri, called Il Guercino (1591–1666). *Two Seated Women*. Red chalk, partly stumped, 11 x 15 1/8 in. (27.9 x 38.4 cm). The Ashmolean Museum, Oxford.

6.5 Victor Hugo (1591–1666). *Castle Above a Lake*. Brush and brown wash. The British Museum, London.

6.6 John Constable (1805–81). *View of the Stour with Dedham Church in the Distance*, c. 1832–36. Pencil and sepia wash, 8 1/2 x 6 3/4 in. (22 x 16.7 cm). The Victoria and Albert Museum, London.

6.7 Georges Seurat (1859–91). *Family Group. Taste in the High Life*. Charcoal on paper, 9 1/2 x 12 1/2 in. (24 x 31.7 cm). Private Collection.

7.1 Vincent Van Gogh (1853–90). *La Crau from Montmajour*, 1888. Pen and ink and chalk, 19 1/3 x 24 in. (49 x 61 cm). The British Museum, London. Photo: The Fotomas Index

7.2 Henry Fuseli (1741–1825). *Cassandra Raving*. Red and gray washes, heightened with white, over indications in pencil and black chalk, 13 2/3 x 9 in. (34.6 x 22.8 cm). The Ashmolean Museum, Oxford.

7.5 Anonymous, French, 19th century. *Reclining figure*. Pencil and watercolor. The Whitworth Art Gallery, Manchester.

7.6 Samuel Palmer (1805–81). *Self-portrait*, 1824-25. Black chalk heightened with white on paper, 11 1/2 x 9 (29.1 x 22.9 cm). The Ashmolean Museum, Oxford.

7.7 Jean-Auguste-Dominique Ingres (1780–1867). *Sir John Hay and his Sister*, 1816. Pencil, 11 1/4 x 8 1/2 in (29 x 22.2 cm). The British Museum, London.

7.8 Hans Holbein (1497/8–1543). *Sir Thomas Elyot*, 1532–33. Chalk and pen and ink, 11 x 9 in (28.5 x 20.3 cm). The Royal Collection © 2005, Her Majesty Queen Elizabeth II.

7.10 Sebastiano Serlio (1475–1554). *Stage Set for a Comedy*, taken from the *Architettura*, Paris, 1545. Photo: The Fotomas Index.

7.11 Vincent Van Gogh (1853–90). *Pollard Birches and Shepherd*, 1884. Pen and ink and graphite, 15 3/8 x 21 1/4 in (39.5 x 54.5 cm). The Van Gogh Museum, Amsterdam.

7.13 Harold Gilman (1876–1919). *Seascape, Canada*. Pen and ink. The Ashmolean Museum, Oxford.

7.14 Ben Nicholson (1894–1982). *January 4 1953 (Thorpe, Wharfedale in snow)*. Oil wash and pencil on paper, 14 1/2 x 21 7/8 in (36.7 x 55.5 cm). Pallant House Gallery, Chichester (Hussey Bequest, Chichester District Council, 1985). © Angela Verren-Taunt 2005. All rights reserved, DACS.

7.15 Henri Matisse (1869–1954). *Le Coupe de Raisin*, 1915. Pencil on paper, 21 3/4 x 14 3/4 in (55 x 36 cm). Private Collection. © Succession H Matisse/DACS 2005.

7.17 Claude Lorrain (1600–82). *The Tiber above Rome*. Brush with brown wash. The British Museum, London. Photo: The Fotomas Index

8.1 Rembrandt van Rijn (1606–69). *Jael Killing Sisera*. Pen and brown ink, 6 7/8 x 9 3/4 in. (17.4 x 25.5 cm). The Ashmolean Museum, Oxford.

8.2 Jackson Pollock (1912–56). *Untitled*, 1943. Pen and black ink, gray and black wash, gouache, and red chalk, 18 7/8 x 24 3/4 in (47.9 x 61.3 cm). The Pierpont Morgan Library, New York. © ARS, NY and DACS, London 2005.

9.1 Samuel Palmer (1805–81). *Early Morning*, 1825. Pen and brush in sepia, 74 x 91 1/3 in (188 x 232 cm). The Ashmolean Museum, Oxford.

9.2 Pablo Picasso (1881–1973). *Minotaur and Dead Mare in Front of a Cave*, 1936. Gouache and Indian ink on paper, 17 1/3 x 21 2/5 in (44 x 54.4 cm). Musée Picasso, Paris. © Succession Picasso/DACS 2005.

10.1 Georges Seurat (1859–91). *Le Laboureur*. Crayon and conté on paper. Musée du Louvre, D.A.G. (fonds Orsay). RMN © RMN. Photo: © Michele Bellot

10.2 Jean-Auguste-Dominique Ingres (1780–1867). *Seated Nude*. Pencil. Private Collection. Photo: The Fotomas Index.

10.3 Willem de Kooning (1904–97). *Untitled*, 1950. Black enamel type paint on off-white wove paper, 19 1/8 x 25 5/8 in (48.5 x 65.1 cm). Gift of Katharine Kuh, The Art Institute of Chicago.

10.4 Richard Diebenkorn (1922–93). *Seated Woman, Patterned Robe*, 1963. Conté crayon, charcoal, and brush and ink wash, 17 x 13 7/8 in (43.2 x 35.2 cm). The Baltimore Museum of Art: Thomas E. Benesch Memorial Collection, BMA 1970.21.3.

10.5 Pablo Picasso (1881–1973). *Minotaur*, 1933. Pencil with pasted papers and cloth tacked on wood, 19 x 16 in (48.5 x 41 cm). Museum of Modern Art, New York. © Succession Picasso/DACS 2005. © 2005, Digital Image, The Museum of Modern Art, New York/Scala, Florence.

11.1 Canaletto (1697–1768). *Architectural Capriccio*, Pen and ink and wash over pencil, 9 4/5 x 15 in (25.1 x 38.4 cm). Victoria and Albert Museum, London.

11.2 Lyonel Feininger (1871–1956). *Vollersroda*, 1918. Ink on paper, 7 7/8 x 9 7/8 in (20 x 25 cm). Los Angeles County Museum of Art, Graphics Arts Council Fund. © DACS 2005.

11.3 Edward Bawden (1903–89). *Menelik's Palace: The Old Gebbi*. Chalk, ink, watercolor on paper, 18 1/4 x 4 5/8 in (46.3 x 11.6 cm). The Imperial War Museum, London.

11.4 Saul Steinberg (1914–99). *View of the World from 9th Avenue*, 1975. Graphite and crayon on paper, 20 x 15 in (50.8 x 38.1 cm). © 2005 The Saul Steinberg Foundation/ARS, NY and DACS, London. Photo: Pace Wildenstein.

11.9 Pierre Bonnard (1867–1947). *Standing Nude on a Round Mat*. Pencil. Private Collection. © ADAGP Paris. Photo: The Fotomas Index.

11.10 Hokusai (1760–1849). *Hanashita-e* from the series *One Hundred Poets*. Ink with tip of brush, 10 1/2 x 14 7/8 in. (27.1 x 38.3 cm). The Fitzwilliam Museum, Cambridge.

11.11 David Hockney (b. 1937). *Self-portrait with a Blue Guitar*, 1977. Oil on canvas, 5 x 6 ft (1.5 x 1.8 m). Courtesy David Hockney. © David Hockney.

11.12 Jean-Honoré Fragonard (1732–1806). *Genoa, Staircase of the Palazzo Balbi*. Black chalk. The British Museum, London.

11.13 Charles Lewis (1753-95), *A Bird's Eye View of the Garden of Dr. Charles Greville, 2 Barton Street, Gloucester*, late 1760s. Pencil, pen and ink, and wash, 9 1/4 x 15 in (23.5 x 31.8 cm). Collection of Mrs Paul Mellon, Oak Spring Library, Upperville, Virginia. Photo: Bret Payne.

11.14 Anonymous. *New York, Plan of Manhattan, Long Island, the Hudson River and New Amsterdam*, 1664. Materials, Dimensions. The British Library, London. Photo: The Bridgeman Art Library.

12.1 Max Klinger (1857–1920). *Action* from *Paraphrase on the Discovery of a Glove*, 1878 (published 1881). Etching, 11 3/4 x 8 1/4 in (29.9 x 21 cm).

12.2 Umberto Boccioni (1882–1916). *Dynamism of a Cyclist*. 1913. Pen and ink on paper. Esoterick Foundation, London. Photo: The Bridgeman Art Library.

12.3 Wassily Kandinsky (1866–1944), *Black Relationship*, 1924. Watercolor and pen and ink, 14 1/2 x 14 1/2 in. (36.8 x 36.2 cm). The Museum of Modern Art, New York. Acquired through the Lillie P. Bliss Bequest, 341.49.

13.1 and 13.2 Theo Van Doesburg (1883–1931). Seven studies for the composition *Rhythm of a Russian Dance*, 1917–18 and *Rhythm of a Russian Dance*, 1918. Drawings: pencil, pen, and ink, formats from 3 1/4 x 2 5/8 to 8 x 5 to 8 x 5 1/4 (8.2 x 6.7 to 20.3 x 13.3 cm); Painting: oil on canvas, 53 1/2 x 24 1/4 in. (135.9 x 61.16 cm). The Museum of Modern Art, New York.

13.3 and 13.4 Frank Auerbach (b. 1931). Study for *Park Village East, Winter* and *Park Village East, Winter*, 1998–99. Drawing: Felt tip pen, pencil, and crayon on paper, 7 3/4 x 11 1/2 in. (20 x 29.7 cm), Painting: Oil on canvas, 40 x 60 in. (101.6 x 153 cm). Amgueddfeydd ac Orielau Cenedlaethol Cymru (National Museum and Galleries of Wales). © The Artist.

13.5 Fernand Léger (1881–1955). *Face and Hands*, 1952. Brush and ink and touches of pencil, 26 x 19 3/4 in (66 x 50.1 cm). Museum of Modern Art, New York. Mrs Wendell T. Bush Fund, 18.53. © ADAGP, Paris and DACS, London 2005.

13.6 Piet Mondrian (1872–1944) *Study for the Gray Tree*, 1911. Black crayon on paper, 23/22 1/4 x 34 1/8/34 in (58.4/57.7 x 86.5/86.2 cm). Gemeentemuseum, The Hague. © 2005 Mondrian/Holtzman Trust c/o hcr@hcrinternational.com

13.7 and 13.8 Harold Gilman (1876–1919) Study for *Mrs Mounter* and *Mrs Mounter*, 1916–17. Drawing: Pen and ink, 11 1/4 x 7 1/4 in. (28.6 x 18.4 cm). The Ashmolean Museum, Oxford. Painting: oil on canvas, 36 1/8 x 24 1/4 in. (91.8 x 61.5 cm). Walker Art Gallery, Liverpool.

13.9 Henri Matisse (1869–1954) *Reclining Woman*, 1926. Charcoal and estompe, 18 7/8 x 24 3/4 in. (48 x 62.8 cm). The Baltimore Museum of Art: The Cone Collection, formed by Dr Claribel Cone and Miss Etta Cone of Baltimore, Maryland. BMA 1950.12.52. © Succession H Matisse/DACS 2005.

13.10 Pierre Bonnard (1867–1947). *Paysage au Bord de la Mer*, 1922. Private Collection. Courtesy of Wolsely Fine Arts, London. © ADAGP, Paris. Photo: Rodney Todd-White.

14.1 After Edouard Manet (1832–83). *Man on Crutches*. Graphite with reed pen and black ink. The Ashmolean Museum, Oxford.

14.2 Stanley Spencer (1891–1959). *Self-portrait*. Crayon, 15 3/4 x 8 5/8 in. (40 x 22 cm). Williamson Art Gallery and Museum, Birkenhead.

14.3 and 14.4 Edward Degas (1834–1917). *Three Studies of a Dancer*, 1879–80 and *Little Dancer Aged Fourteen (Petite Danseuse de Quatorze Ans)*, c. 1920–21, from 1881 wax model. Drawing: black chalk highlighted with white on pink paper, 18 7/8 x 24 13/16 in (47.9 x 63 cm). Private Collection. Courtesy Marianne Feilchenfeldt, Zürich. Photo: Reto Pedrini. Sculpture: plaster, fabric, 3 ft 2 1/2 in (97.8 cm). Joslyn Art Museum, Nebraska. Gift of M. Knoedler & Co., Inc., New York (1971.271).

14.5 Ben Nicholson (1894–1982). *1961 (Palästra, Olympia)*. 1961, Pencil and oil wash on paper, 23 5/8 x 18 1/2 in (60 x 47 cm). Aberdeen Art Gallery and Museums Collection. © Angela Verren-Taunt 2005. All Rights Reserved, DACS.

14.6 Henri Matisse (1869–1954). *Group of Trees at L'Estaque*, 1884. Charcoal on paper, 24 1/2 x 18 3/4 in (62.3 x 47.6 cm). Musée National d'Art Moderne, Centre Georges Pompidou, Paris. © Succession H Matisse/DACS 2005. © Photo CNAC/MNAM Dist. RMN.

15.1 Michelangelo Buonarroti (1475–1564). *Portrait of a Young Boy*, c. 1532. Black chalk on paper, 16 1/6 x 11 2/5 in. (41 x 29 cm). British Museum, London. Photo: The Bridgeman Art Library.

15.2 Amedeo Modigliani (1884–1920). *Head – Raimondo*, 1915. Pencil on paper. The Barnes Foundation, Pennsylvania. © The Barnes Foundation. Photo: The Bridgeman Art Library.

15.3 Frank Auerbach (b. 1931). *Jake*, 1990. Etching, from an edition of 50, 10 1/4 x 8 1/2 in. (26 x 21.5 cm). Private Collection. © The Artist. Photo: The Bridgeman Art Library.

15.4 Pablo Picasso (1881–1973). *Frenhofer at work on his "Unknown Masterpiece,"* illustration for the story "Le Chef d'Oeuvre Inconnu" by Honoré de Balzac. Etching, 7 1/2 x 11 in (19 x 28 cm). The Stapleton Collection. © Succession Picasso/DACS 2005. Photo: The Bridgeman Art Library.

3.1, 3.2, 3.3, 3.4, Page 37, 4.1, 4.2, 4.5 (diagrams x2), **4.6, 4.7, 4.9, 4.10, Pages 60 and 61, 6.1, 6.2, Page 72, 7.3, 7.4, 7.9, 7.12, 7.16, Page 88, 8.3, Page 94, Pages 98 and 99, Page 100, 11.5, 11.6, 11.7, 11.8, Page 122, Page 140, Pages 156 to 159** are all after designs by the author.